12·95

65154

GAUGUIN

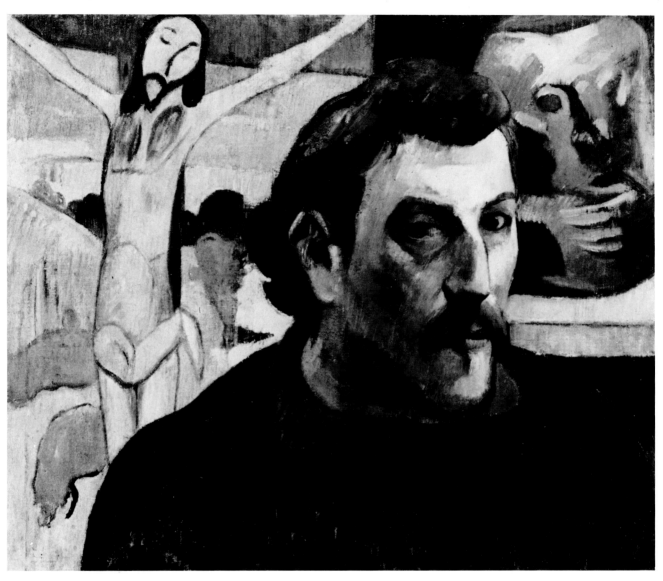

SELF-PORTRAIT WITH YELLOW CHRIST. 1890. *Former collection Maurice-Denis*

PAUL

GAUGUIN

ROBERT GOLDWATER

THAMES AND HUDSON

First published in Great Britain in 1985
by Thames and Hudson Ltd, London

This is a concise edition of Robert Goldwater's *Gauguin*,
originally published in 1957

Printed and bound in Japan

CONTENTS

GAUGUIN

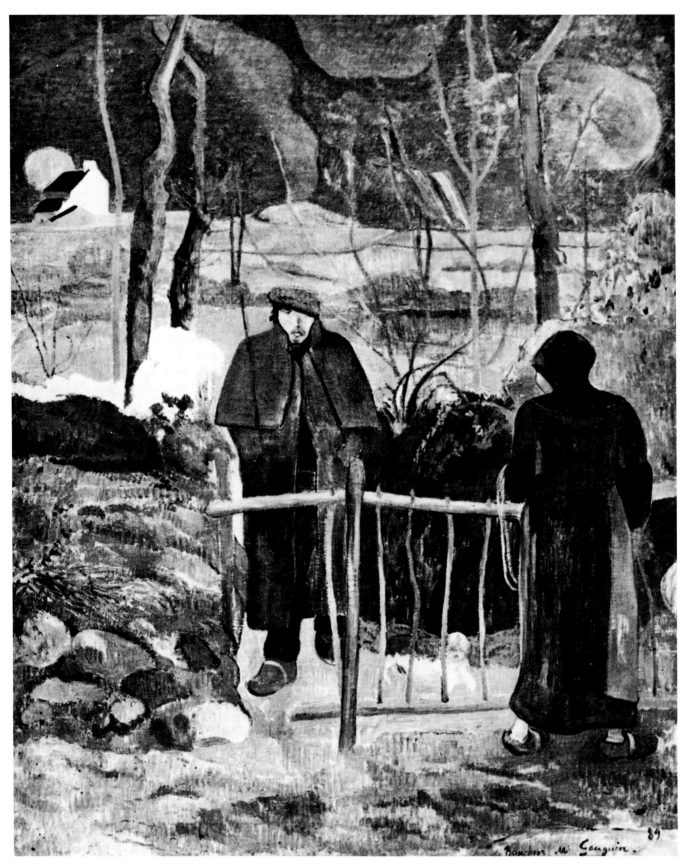

BONJOUR MONSIEUR GAUGUIN. 1889. Oil, 44½ x 36¼″. *Museum of Modern Art, Prague*

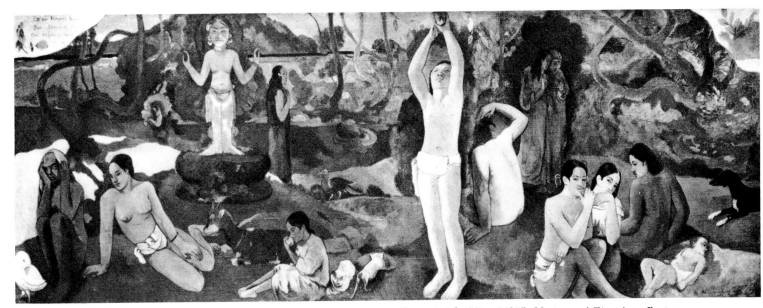

WHERE DO WE COME FROM? WHAT ARE WE? WHERE ARE WE GOING? 1897. Oil, 55½ x 148¼". *Museum of Fine Arts, Boston*
(see colorplates, pages 110, 112, 114)

BELOW: Letter of February, 1898 to Daniel de Monfreid with a drawing of WHERE DO WE COME FROM?
Collection Mme. A. Joly-Ségalen, Bourg-la-Reine (Seine) France

THE FOUR FATHERS OF MODERN PAINTING were very different men. Although they lived and worked at the same time and during several crucial years in the same milieu, and were acutely aware of each other as personalities—collaborators or rivals—their backgrounds, temperaments, and worldly positions varied widely. They were also very different artists. The "Post-Impressionist" label they share is correct in its historical implications, its reference to a common basis in Impressionism, and its suggestion that they all built upon that immediately preceding style. Yet the label cannot attenuate the profoundly individual quality of their achievements.

Nevertheless, and with good reason, they remain associated in our sentiments. These four men—Cézanne, Seurat, Van Gogh, and Gauguin—did have this in common: to a remarkable degree their art was born of a similar persistence and determination. Their work and their lives are marked by a victorious struggle against odds that has become a symbol, a standard of triumphant integrity against which other artists are judged, and judge themselves. Much

more than the Impressionists who preceded them (who painted with a facility whose evidence still gives us an expansive pleasure today), and than the Fauves and Cubists who followed and learned from them (who found their own styles with comparative rapidity), the work of these four men was the result

of a sustained personal effort of a sort unmatched in the history of Western painting.

We are accustomed to think of this struggle, in purely economic and social terms: the poverty suffered by Van Gogh and Gauguin, the critical hostility and commercial failure met by all four painters. But neither Cézanne nor Seurat starved and there was no outward drama in their lives. Nevertheless there was conflict within themselves of such intensity that it made them appear, in the ordinary sense, untalented. The will to create, to invent a method to match a vision, the concentration on the artistic goal to be achieved against all obstacles, was paramount. Their determination was esthetic. Seurat showed it in his relentless day by day production, the very opposite of the inspirational flash; Cézanne in his willingness to begin again, and yet again, literally discarding paintings along the way, to come one step closer to that ideal union of the permanent and the fleeting which he carried in his mind's eye; Van Gogh in the

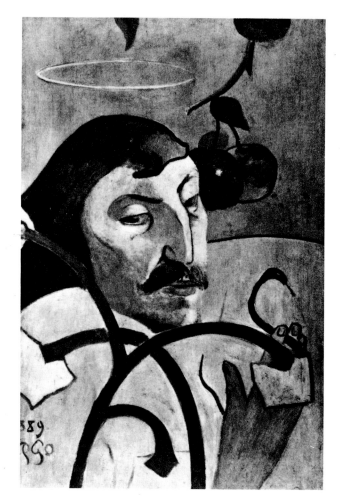

SELF-PORTRAIT WITH HALO. 1889. Oil on wood, 31¼ x 20¼″
National Gallery of Art, Washington, D.C. (Coll. Chester Dale)

PHOTOGRAPH OF PAUL GAUGUIN. 1888
Collection Mme. A. Joly-Ségalen, Bourg-la-Reine (Seine) France

intensity of creation that wore him out in a decade. And Gauguin demonstrated it over twenty years in the iron-willed pertinacity that took him from Paris to Brittany, from Brittany to Martinique and Tahiti, and finally from Tahiti to the Marquesas, always in order to paint.

The odds against Gauguin were economic as well as esthetic. Because they were self-created odds, he even more than his peers in painting, became a symbol. He was the idealist who gave up financial security, forsook the comforts of home, wife, and children, left friends and a familiar countryside behind, in order to pursue an artistic vision capable of realization only through suffering. He was also, however (reverse of the romantic coin), the epicurean, the voluptuary, thinking only of himself, who had accepted Baudelaire's *Invitation to the Voyage*, and had gone to live in an exotic and luxuriant Isle of Cythera in the South Seas. There is, as we shall see, some truth to both these views. Gauguin was heir to a self-conscious romantic tradition, and he had a

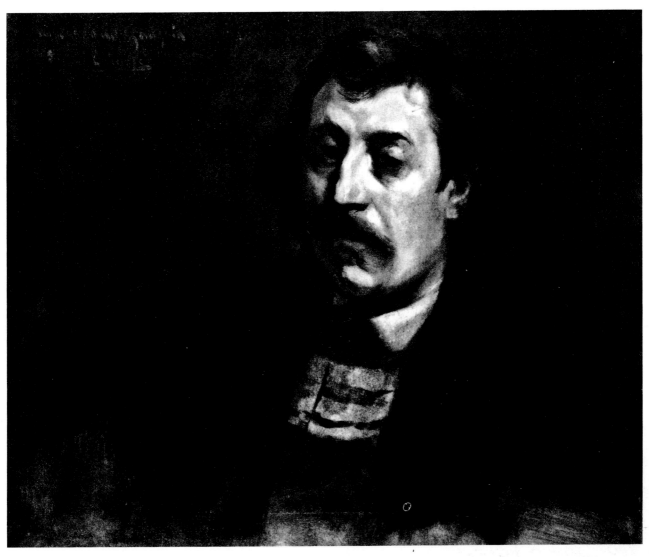

Eugène Carrière: PORTRAIT OF GAUGUIN. 1891. Oil, 26 x 30″. *Collection Mrs. Fred T. Murphy, Grosse Pointe, Michigan*

highly dramatic sense of the role he played for what he fondly hoped was a watching world. On the other hand there is no doubt that he made sacrifices for his art, that both spiritually and physically he suffered in order to go on painting. The difficulty indeed is to get at the nature of that alternation between external play-acting and internal anguish, and to perceive that the artist underlay both.

BECAUSE THE EVENTS of Gauguin's life are so much easier to relate than the story of his art—and of his relation to his art—they have been dramatized until it seems as if his existence was nothing but a swift succession of explosive incidents, with no time left for painting. Those incidents of course occurred, and it is a fascinating study to try to apportion their origin: how many were due to external circumstance, and therefore unavoidable: how many were the re-

sult of his true nature, and consequently inevitable; how many did he, in a capricious and ironic way, bring down upon his own head, watching himself as he did so (for Gauguin was possessed of a comic, as well as a tragic spirit).

The reality of his life was quite otherwise than constantly dramatic. There was daily effort, there was boredom, there was hesitation. Each of Gauguin's decisions was long and difficult, into each went pondering and doubt, and even fear, until at last the combined pressure of character and accident, of economic circumstance and the absolute necessity to go on painting, forced him to action. At each turning point—from the slow transformation of the collecting amateur into the professional artist (the decision of January, 1883 had years of built up pressure behind it) until the final move in 1901 to the Marquesas (a change that had been contemplated almost from the

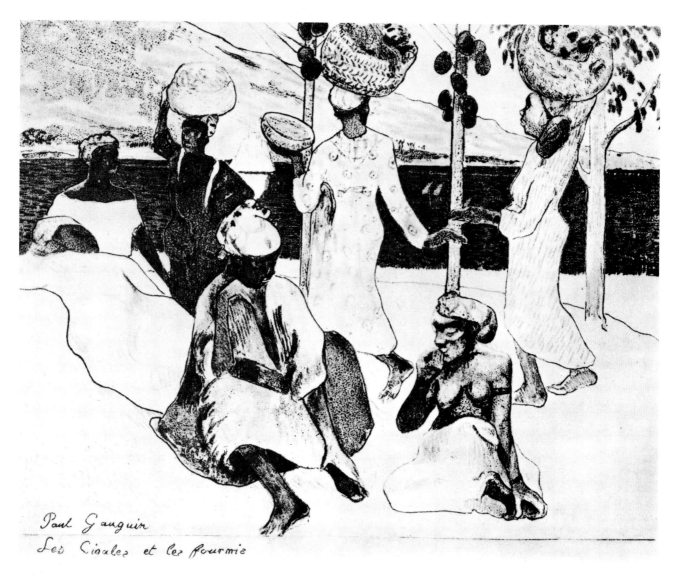

THE GRASSHOPPERS AND THE ANTS, SOUVENIRS OF MARTINIQUE. c. 1889. Lithograph, 8 x 10¼".
National Gallery of Art, Washington, D.C. (Lessing Rosenwald Collection)

beginning of his South Sea stay), and above all in the reluctant separation from his family—one senses the holding back, the desire to hold on to what he has, until the accumulation of immediate difficulties has forced the creation of a mirage that carries him forward into the future.

When he moves to Rouen with his family because life will be cheaper there, he at the same time convinces himself (as Pissarro wrote to his son Lucien) that the wealthy Rouennais will easily be induced to buy his pictures. When in Paris, in 1886, with his son Clovis sick, he is forced to paste up bill-posters at five francs a day, he is sure that he will soon be named director of the company's Spanish branch (not yet founded!) and will gradually gather his other children around him. When the next year he leaves Paris ("which is a desert for a poor man")

for Panama he imagines that his brother-in-law, Juan Uribe, will help him (though he never has before), and that besides he will make a fortune in a prospective business affair. Upon his return he again decides he can live on his ceramics, which his friends and a collector or two have praised. And so it goes from scheme to scheme, with complete confidence up to the moment when each one collapses, whereupon he exclaims, "One more thing that has slipped out of my hands." With Pissarro, one is forced to conclude that Gauguin is naive, but that given his constantly desperate situation his naivete and the recurring growth of optimism it nourished was a necessity. And one suspects that Gauguin, living a hand to mouth existence which could hardly get any worse, was not entirely unaware of the self-delusion.

The pattern of his journeys to distant places is not

dissimilar. In each instance despair of the present and hope for the future are inextricably entangled. The "Inca" blood of Gauguin's Peruvian grandmother has been given credit for his love of the primitive and the exotic. One need hardly search so far. A tradition continuous since *Paul et Virginie* taught him to believe that at the end of the rainbow he would not need the pot of gold. On the one hand his attitude toward the artist (more than toward art itself) grew out of a romantic tradition that set great store by the simple and the childlike. Long before he thought of going to the South Seas he wrote to his wife, "I am leaving for Panama to live like a savage . . . I am taking my paints and my brushes with me, and there I will steep myself [in nature] far from all men." But once he is in Panama he must go on to Martinique, where upon his arrival he finds "a paradise." In the

light of this vision of the simple and the unspoiled he can quite seriously exclaim, "I am not ridiculous, because I am two things which cannot be ridiculous: a child and a savage." One has but to look at his pictures, read his descriptions of his Tahitian Eve, "The Eve of my choice," to realize that this romantic tradition has licensed him to believe that the child and the savage are the same, and that their intuitive existence is the ideal, happy life. "May the day come (soon perhaps) when I can escape to the woods of a South Sea Island and live there in ecstasy and peace."

Eighteen months later (June, 1891) that wish was realized. But the "terrible itching for the unknown which causes me to commit follies," was not so easily satisfied, nor was the desire for loneliness which he sought out, and then suffered from all his life. Just

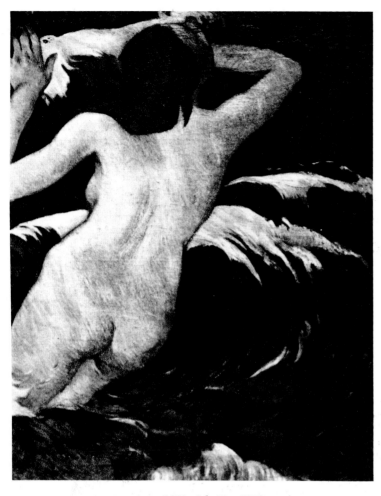

WOMAN IN WAVES. 1889. Oil, 36 x 28¼"
Collection Mr. and Mrs. W. Powell Jones, Gates Mills, Ohio

as he had gone from Panama to Martinique in 1887, and from Pont-Aven to Le Pouldu in 1889, now in Tahiti, although he was installed in the countryside twenty-five miles from the capital, he soon longed to go even farther into the primitive unknown. Less than a year after his arrival he is writing of his wish to go to the island of Dominique (Hiva-Oa) in the Marquesas, "a small island where there are only three Europeans, and the Oceanian is less spoiled by European civilization." Like most of his dreams, which he had to nurse and scheme for, this took a long time to carry out. Nine years later, six after his second arrival in Tahiti and only two before his death he was able to go to live in "complete isolation," once more steeping himself in nature. Three months before he died he wrote, "I am satisfied, here in my solitude."

There is thus no doubt that Gauguin's desire for flight was real; the will o' the wisp escaped him, but it was there before his eyes. To Renoir's famous ironic criticism, "One can paint so well at the Bati-

gnolles" (in Paris), Gauguin gave his unwitting answer from Tahiti, "I am in the midst of work, now that I know the ground and its fragrance, and the Tahitians—whom I render in a very enigmatic fashion—are nonetheless Maoris, and not orientals from the Batignolles. It has taken me nearly a year to arrive at this understanding . . ." But there is also no doubt that in each of his evasions despair helped to inflate the balloon of hope. The almost conscious self-deception, the repeated "I have reason to believe that the future will be better" was made easier by the hopelessness of the reality at hand. Gauguin's flights are always from a place where it costs little to live, to another where it will cost even less. He goes first to Pont-Aven in Brittany because he has heard it is cheap; he leaves for Panama where he expects "to live for nothing"; back in Brittany once again he spends one franc a day for his food, ten centimes for tobacco. The "atelier of the tropics" that he tries so hard to persuade Emile Bernard and Schuffenecker to found with him, projecting it first for Madagascar and then for Tahiti, is based on the belief that "To live like the natives costs nothing. Hunting alone will easily provide food." In Tahiti he moves to the country because the town is not primitive enough, but also because it is cheaper. And in his final removal he goes from Tahiti where life has become "more expensive than in Paris," to "an island in the Marquesas where life is very easy and very cheap."

Only Gauguin's faith, the naivete that Pissarro noticed, and his tremendous physical strength, which despite abuse, starvation, and illness lasted through many years, made possible these repeated beginnings. But he could not go on indefinitely. In Panama, when his plans failed, he could announce, "Well, the mistake has been made; it must be corrected. I leave tomorrow to wield a pick-axe in the isthmus, . . . and when I have saved . . . 600 francs—a matter of two months—I will leave for Martinique." While a month before his death, in his last letter to Daniel de Monfreid, he wrote, "It will be said that all my life I have been condemned to fall, to pick myself up, and to fall again . . . Day by day all my old energy fades away."

G AUGUIN'S HUMAN RELATIONS are largely explained by a similar need for hope, a need that persisted because it was so often deceived. He believed those who made casual promises to buy, built elabo-

14

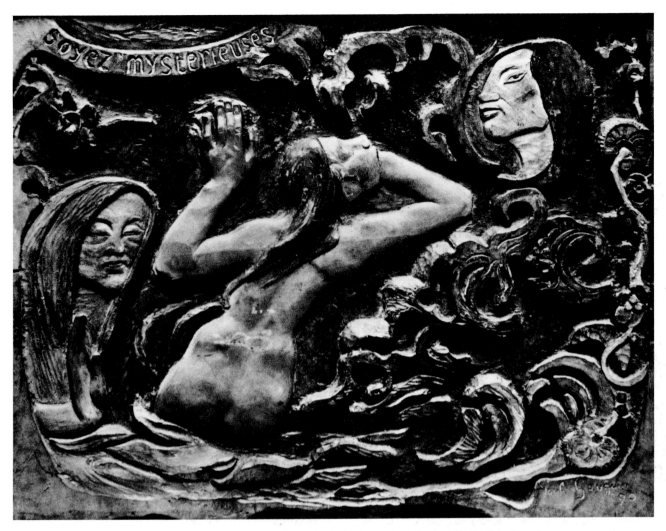

BE MYSTERIOUS. 1890. Painted wood relief. *Formerly collection Emile Schuffenecker*

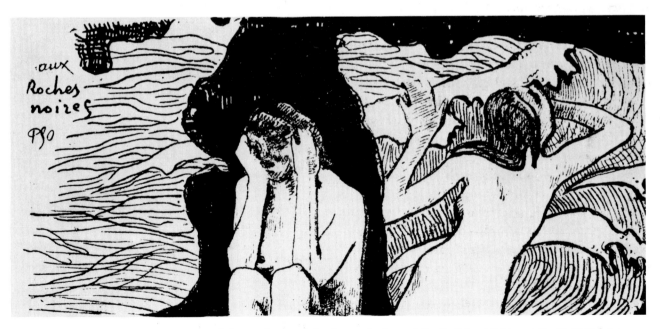

BLACK ROCKS. 1889. First page of the catalogue of the Impressionist and Synthetist exhibition at the Café Volpini.

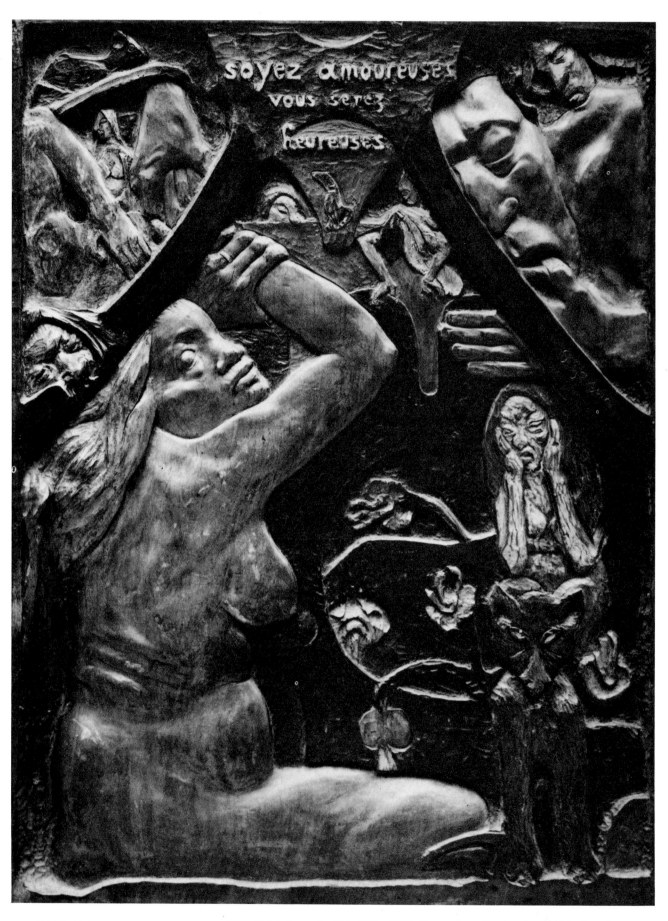

BE IN LOVE, AND YOU WILL BE HAPPY. 1901. Painted wood relief, 38⅛ x 28¾″. *Formerly collection Emile Schuffenecker*

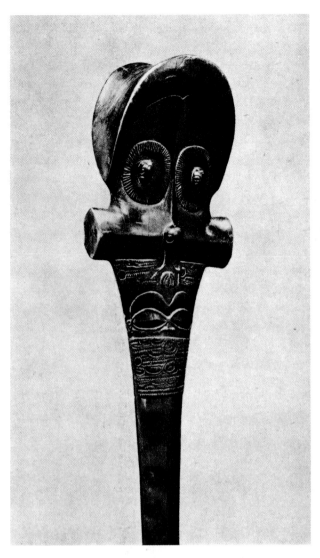

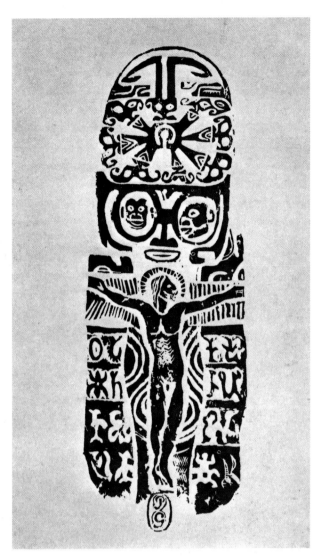

CARVED HEAD OF A CLUB FROM THE MARQUESAS ISLANDS
Wood, whole club 5′ high. *Museum of Primitive Art, New York*

CRUCIFIXION. Woodcut, 15⅞ x 5⅜″
Metropolitan Museum of Art, New York

rate plans upon vague uncertainties that came to nothing, acted upon suggestions that for others were the most casual sort of conversation. Inevitably he was disappointed, and he then reproached other people for deceptions for which he had only himself to blame. Since his letters constitute the major part of the record, it is difficult to know how often promises were really broken, money really owed was never sent. In some instances (Chaudet, Vollard) Gauguin's anger seems to have had just cause; in others, notably that of Schuffenecker who for so long came to his aid at every turn, he seems quickly to have forgotten past kindnesses. But despite his pose of irony and cynicism he was just as quick to count on the good faith of the next met friend or acquaintance. He perhaps appears at his most heartless after the death of Theo van Gogh. Theo's devotion and suffering are never mentioned, although his ability to sell pictures is later employed as an accusation against other dealers. Gauguin takes his death as a personal affront, almost an act committed with the express intent to make him, Gauguin, suffer once more, just when things were about to go well.

For such behavior and such sentiments, he has been called heartless and ungrateful. But many people, neither artists nor as lonely as Gauguin, have accounted the death of someone close to them an unforgivable deception. He was after all as unyielding with himself as he was with his friends. And when we make the balance sheet of his personal relations we should not forget that he was able repeatedly to inspire confidence, to establish the close human contact which gave him the aid he did need. It is not surprising that the hopes of some were disappointed; so were his own, since he set himself an impossible ideal. Yet in several instances—Schuff-

17

enecker, Charles Morice, and above all De Monfreid —Gauguin was able to sustain a long and intimate relationship which, while it was certainly of great practical value to him, was based upon a deep human sympathy and understanding. Gauguin turned bitter when his optimism toward events and people proved unfounded, as indeed so often happened. But had reality counted for Gauguin any more than it did, had he hard-headedly projected the constantly impossible present into an equally impossible future, he could scarcely have continued to paint. The world of illusion he created in his art he carried within himself.

If that illusion was to be sustained a certain faith in his art and in his own genius was required. "I am a great artist and I know it," he writes in 1892 from Tahiti. "It is because I am that I have endured such suffering." To others this attitude often appeared as an unpardonable egotism. Gauguin was more aware of this than is generally assumed. "Were

this not the case," he continues, "in following my own road I would consider myself a brigand; which is, as far as that goes, what I am for many people."

He possessed what Charles Morice called "the legitimate ferocity of a productive egotism," and this was bound to be repugnant to weaker, or more modest characters. Morice, who despite quarrels remained his friend, described his appearance and the impression he made in Paris in the winter of 1890:

"A broad face, massive and bony, a narrow forehead, a nose neither curved nor arched, but as if broken, a thin-lipped mouth without any inflection, heavy eyelids lifting sluggishly over slightly protuberant eyeballs whose bluish pupils rotated in their orbits to glance left or right while his head and bust made almost no effort to turn. There was little charm about this stranger; yet he attracted one by his very personal expression, a mixture of haughty nobility, obviously innate, and of a simplicity that bordered on triviality. It was not long before one realized this

MEYER DE HAAN. c. 1890. Watercolor, 5½ x 7⅞". *Wildenstein & Co., New York*

Pissarro: PORTRAIT OF PAUL GAUGUIN; Gauguin: PORTRAIT OF CAMILLE PISSARRO. 1883. Drawing. *Coll. Paul-Emile Pissarro, France*

mixture was a sign of strength: aristocracy permeated by the proletariat . . . Gauguin's smile had a strangely naive gentleness . . . Above all, this head took on real beauty when its gravity became illuminated, and in the heat of argument intensely blue rays suddenly flashed from his eyes."

It is true that one part of Gauguin was an actor, a showman who knew the value of a personal legend and a public character. He used these as best he could, although other painters have exploited them with greater success. What is more important, he never allowed them to touch the integrity of his art. If he was a proud man he was also a humble, although not a modest artist. He could write to Schuffenecker, "I tell you I will succeed in doing first rate things, I know it, and we will see. You know that in artistic matters, I am always right in the end." But he also wrote to Emile Bernard, "Reading your letter I see we are all somewhat in the same boat. Moments of doubt, results that always fall short of what we have imagined, the lack of encouragement from others, all

this flays us with thorns . . . At bottom, painting is like man—mortal, but living in a constant struggle against matter. If I thought of the absolute, I would cease all efforts even to stay alive." The mixture of pride and humility lasted throughout his life; he was sure of the effort, but doubtful of the result. The year of his death, writing to Daniel de Monfreid (to whom he expressed himself with all candor) he clearly states his frame of mind, "I only ask for two years of health, and not too many money worries, which now have an excessive hold on my nervous temperament, in order to reach a certain maturity in my art. I feel that I am right about art, but will I have the strength to express it in a positive fashion? In any case I will have done my duty, and there will always remain the memory of an artist who has set painting free . . ."

THE MOST DRAMATIC EPISODE in Gauguin's human relationships is of course his separation from his wife and children, and his refusal to work at ordinary

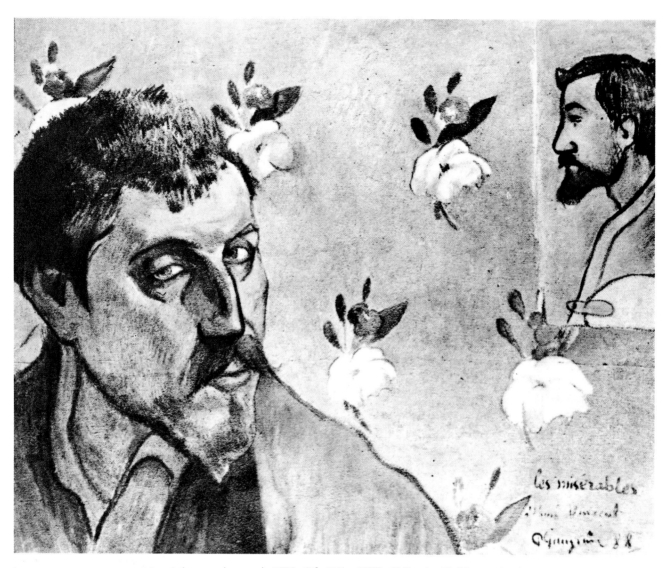

SELF-PORTRAIT (LES MISÉRABLES). 1888. Oil, 28⅛ x 35⅞". *Collection V. W. van Gogh, Laren*
In the upper right corner is a profile of Emile Bernard

pursuits in order to support them. It was also funda-
mental in his estimate of himself. The basic values of
respectable society were opposed to the romantic
tradition of the artist. But although Mette Gad rep-
resented the former and Gauguin the latter, it is
wrong to assume that neither had any insight into
the other. If at this late date we are no longer inter-
ested in taking sides it is important to remember
that at the time there was disappointment and re-
proach, but also self-reproach, and love too. The
length and volume of their correspondence is evi-
dence enough. If Mette Gad was a bourgeois, she
was also apparently fond of her husband, though she
never got over her surprise at having found an artist
instead of the banker she thought she had married.
If Gauguin was a free-living man of strong sexual
impulses, he apparently did love his wife and chil-

dren. In a society where mistresses were a recog-
nized (if not a common) element of the social pat-
tern, Gauguin's *vahiné* were more natural, and we
can believe him when he implies that they did not
encroach upon his love for his legitimate family.

If his wife could not forgive her abandonment and
poverty, Gauguin could not forget his loneliness.
From Pont-Aven in March, 1888, he writes, "You
have the children with you, your compatriots, your
brothers and sisters, your house." He refers again and
again to how he misses the children, is sad that they
do not write to him, not even a card, on his birth-
days. He is saddest of all on hearing (in April, 1897)
of the death of his daughter Aline, dearest to him of
his children. "The news did not move me, trained
long since in suffering; then each day, as memories
came back, the wound opened more deeply, and at

20

this moment I am completely discouraged." And in August, "I have just lost my daughter. I no longer love God. Like my mother she was called Aline; everyone loves after his own fashion, for some love is most intense at the grave, for others—I do not know. Her tomb far away, the flowers, all that is an illusion. Her tomb is here near me; my tears are the living flowers." This was his final letter, never answered by his wife.

Given the situation, and their total separation, it is remarkable that the correspondence lasted as long as it did. The letters attest to real affection on both sides. Gauguin sprinkles his liberally with insults, at which he was certainly a master. Of these the most frequent· was a variation on the sentence (from his letter of September, 1890), "I believe that affection is proportional to money." But he was also adept at

suggesting that his poor wife was rather stupid. Nevertheless she answered, although irregularly, and by ignoring his questions in a way that often infuriated him, starved as he was for news of any kind. And he continued, at intervals, to proclaim his affection, to plan for a better future, to predict, whenever there was the slightest turn for the better in his affairs, that he would support them all by the sale of his paintings. "Your letters have given me pleasure, and have also produced an overwhelming sadness. If only we detested each other . . ." (August, 1887). "You must forgive me if I don't send you more [money] at the moment. I am on the point of being launched and must make a supreme effort for my painting . . ." (February, 1888). "I believe I will be able to help you generously in a year, and I will as soon as I can." (March, 1888). "I wanted in spite of

PORTRAIT OF VAN GOGH. 1888. Oil, 28¾ x 36½". *Collection V. W. van Gogh, Laren*

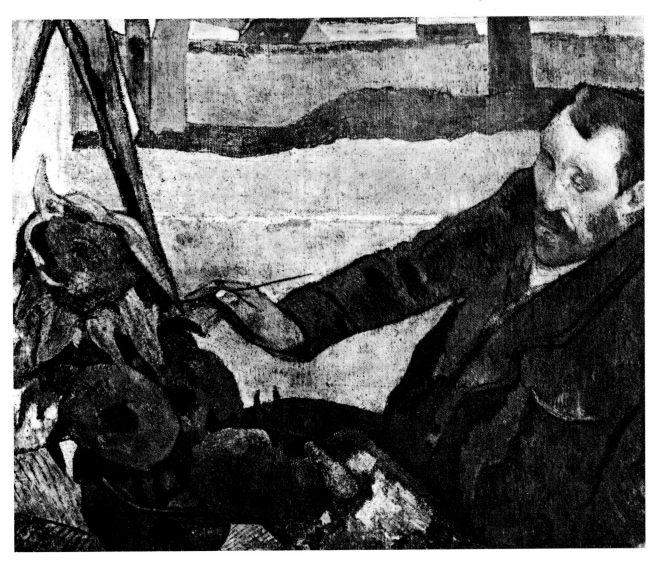

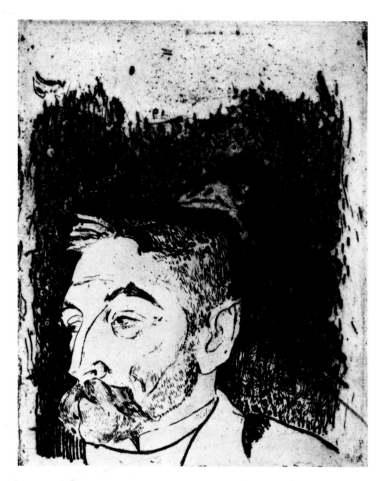

PORTRAIT OF STÉPHANE MALLARMÉ. 1891. Etching, 7-3/16 x 5-11/16"
The Museum of Modern Art, New York (Given anonymously)

the certitude my conscience gave me, to consult others (men who counted) to know if I was doing my duty. They all agree with me that my business is art, that it is my capital, the future of my children, the honor of the name I have given them . . ." (June, 1889).

No doubt Gauguin's was an emotional nature, turning easily from hostility to self-pity and sentiment. Upon his departure for Tahiti, in March, 1891, he addresses his wife, "My adored Mette, an adoration often full of bitterness," and predicts that though the present is difficult ". . . the future is assured, and I will be happy—very happy if you will share it with me." Here is that optimism which seems so foolish in hindsight (though it was perhaps justifiable at the time), but here also is a real and enduring affection, and a hope. Like all Gauguin's hopes it persisted beyond the point of reasonable expectation, yet in his own curious and self-centered way it was sincere. In 1902 he writes to Daniel de Monfreid: "I have still no news [of my wife] and my children know me less and less. Ah well! The scar heals little by little in my loneliness." Perhaps Gau-

guin best characterized his mixture of calculation and emotion, egotism and devotion, when he sent one of his ceramics to Madeleine Bernard and saw in it a symbol of his own nature: "The vase is very cold, and yet it has withstood an interior heat of 1600 degrees."

OF THE GREAT MASTERS who built upon Impressionism, Gauguin transformed it the most. Indeed he was the only one who at last set himself in final opposition to it, although to the end he abjured all attempts to endow him with a "system." And yet of the four Post-Impressionist masters he was perhaps an Impressionist the longest. From his beginnings as an amateur painter in the middle seventies (his *Pont d'Iéna*, for example, looks much like an early Monet), until his trip to Martinique in the spring of 1887, he was allied with the Impressionist group. His first interest in art, stimulated by his patron Gustave Arosa, began as a collector of their paintings. He started his own career as a painter under the tutelage of Pissarro (who became the determined enemy of his later style), and he exhibited with them from 1881 until 1886. Throughout this period his works, both sculpture and painting, show occasional signs of academic realism and conventional genre, and sometimes, as in his famous nude of 1880 (page 48) of a more fundamental honesty of vision that would have pleased Courbet; but on the whole he was absorbing the Impressionist style with a professional thoroughness that disturbed those who had sponsored him simply as a gifted collector.

It was of enormous advantage to Gauguin to be able, almost at once, to plunge into the most progressive style of his period. He never had to go through a truly academic phase, and had almost no set conventions to overcome; he had begun his career late, but we can see now that here was a short-cut that more than made up for lost time. The bright palette, the broken color, the angular view, the esthetic absorption in the surface spectacle of nature, its light and its atmosphere, the gay and pleasant subject, all these Gauguin briefly made his own. The influence of Renoir as of Monet is discernible in both theme and handling. Yet it is hardly astonishing if our hindsight of today perceives suggestions of the style that is to come. In some of these canvases there are signs of the flattening of Impressionist space, the increased smoothness of surface and broadness of color, the emphasis on continuous outline that are the marks of

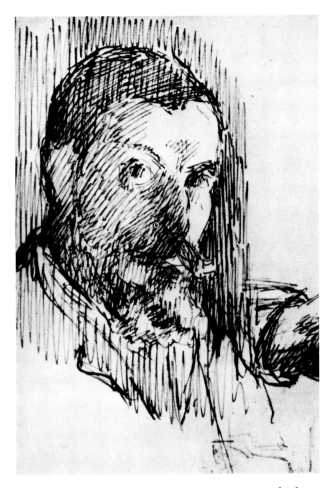

Daniel de Monfreid: SELF-PORTRAIT. c. 1893. Pen and ink
Collection Mme. Agnes Huc de Monfreid, Paris

Here, between the summer of 1888 and the winter of 1890 he turned from Impressionism to "symbolism" from a transcription of nature to an interpretation, from rendering a corner, to suggesting a totality. There has been disagreement as to who originated the new style, Gauguin, or his younger friends (and disciples?) Emile Bernard (page 29) or Louis Anquetin. Gauguin himself was bitter about the sometimes inadvertent, sometimes deliberate implication of critics that Bernard and Anquetin were the creators of "cloisonnisme" or "synthetism" and he but a follower. It is an argument that can never be settled by insisting upon a "sole begetter," or pointing out the precedence of individual pictures or separate statements. These simply show that even before the electric meeting of Gauguin and Bernard at Pont-Aven in August, 1888 there were individual

LETTER TO DANIEL DE MONFREID with a sketch
Collection Mme. A. Joly-Ségalen, Bourg-la-Reine (Seine) France

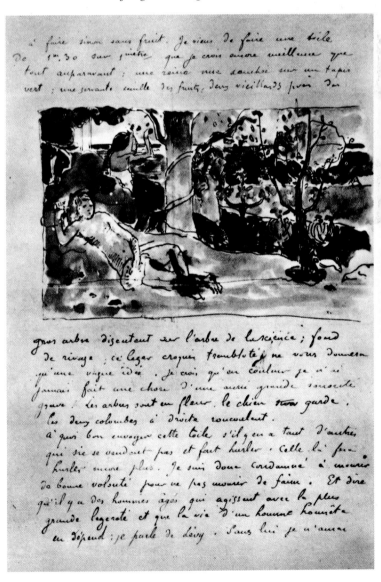

the revolutionary canvases of the next few years. Even before the Martinique trip Gauguin's color has begun to change towards close rather than contrasting harmonies, and mixed, instead of primary and secondary hues. His figures begin to bend into closed contours that suggest the poetic mood of his later work. Already there are still lifes and interiors which have close-up views and spatial constriction that make one think of the Vuillard of ten years later. And already, in Copenhagen, Gauguin is rebelling, not only against the supposed good sense of a stifling society, but also against a reasonable art. "Work freely and madly and you will make progress," he writes in 1885. "Above all don't sweat over your picture; a great emotion can be translated immediately; dream over it and look for its simplest form." The few months in Martinique, with its simple life, its suffusion of nature, its brilliant colors, and clarity of light, only reinforced the tendencies toward decorative symbolism. These he was now to develop further.

Gauguin's characteristic style was born in Brittany.

CROUCHED TAHITIAN WOMAN. c. 1896. Pencil. *The Art Institute of Chicago*

impulses leading in the same direction. (Had it been otherwise that encounter would not have been so fateful or so fruitful.) From then on Gauguin and his immediate friends were in such close contact that mutual inspiration was inevitable. Besides, the more we learn about the period, and the more carefully we read the documents that have long been there for us to see, the clearer it becomes that the ideas to which Gauguin gave his own personal form were in the air, shared not by painters alone, but by poets and musicians as well.

The desire to render feeling directly by the "abstract" equivalent of line and shape and color—above all color, is present in both the painting and the theorizing of Van Gogh and Seurat. Van Gogh wrote of the "terrible" green and red of his *Night Café* at Arles by whose hue and contrast he wished to express the atmosphere of a sinful place where a man might lose his soul; and later (being more literary in his first conception of a picture than Gauguin) of his desire "To express hope by some star, the eagerness of a soul by a sunset radiance," emotions which he embodies directly in the energy and organization of

his landscape renderings. Seurat's approach was more analytic and deliberate, but he was in his own way concerned with the same problem. His theory (which he put into his practice) of the "simultaneous contrast of lines, colors, and tones" allowed him to parallel the mood of his subject—sad, or calm, or gay— through such "abstract" elements of form, and so to embody and express that mood. The Hegelian notion of the "musical," i.e. the non-representational and suggestive tendency of all art, abounds in the literary and artistic theory of the time. Whether expounded with a scientific or a mystical bias, the attitude is the same.

Already as early as January, 1885, during his abortive attempt to live with his wife's family in Copenhagen, Gauguin was considering these problems. In a letter to Emile Schuffenecker he wrote, "All our five senses reach the brain directly, having been affected by an infinity of things [in a way] that no education can destroy. I conclude from this that . . . there are noble tones, others that are common; quiet and consoling harmonies, and others whose boldness is exciting." As early as 1886 Gauguin refers to him-

24

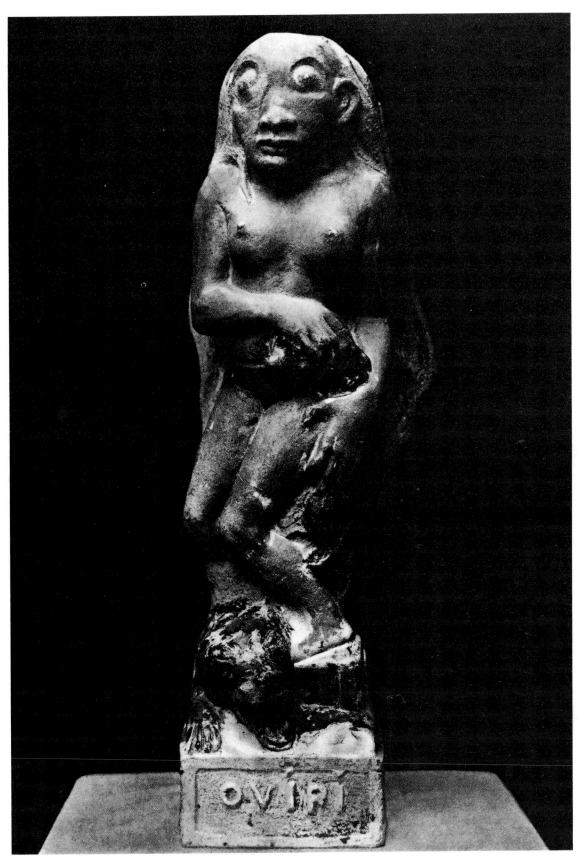

OVIRI THE SAVAGE. c. 1891-93. Terra cotta. *Private collection, France*

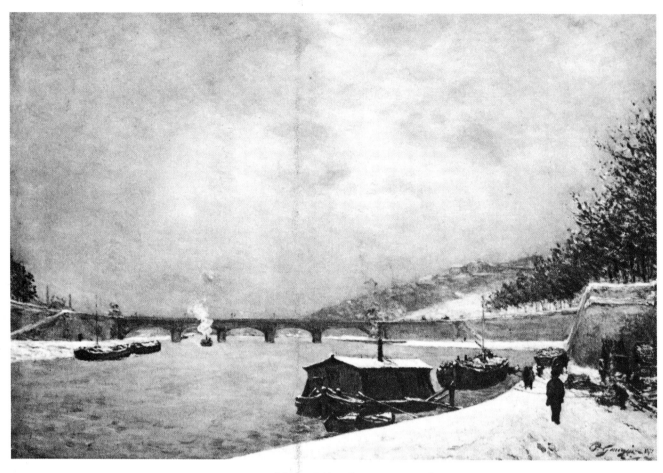

THE SEINE AT THE PONT D'IÉNA. 1875. Oil, 25¼ x 36¼". *The Louvre, Paris*

self as a "synthetist" though he continues also to ally himself with Impressionism. The immediate, conscious sources of the new style were various—Japanese prints, the folk woodcuts called *images d'Epinal*, medieval stained glass windows, but also "primitive" artists of the Renaissance tradition. Perhaps Gauguin was not at once aware of the importance of all of these. But in his room in the Pension Gloanec he hung reproductions of Botticelli's *Venus*, Fra Angelico's *Annunciation*, the *Olympia* of Manet (whose style was once compared to playing cards), and prints by Utamaro. He was much aware of Degas, himself strongly influenced by Japanese prints, and in July, 1888 (before Bernard's arrival) he refers to one of his own pictures as "quite Japanese, by a savage from Peru."

What is certain is that whatever his sources of inspiration (and Emile Bernard was among them) Gauguin carries further than anyone else the ideas expressed in his famous letter to Schuffenecker of August, 1888, "A word of advice; don't copy nature

too much. Art is an abstraction; derive this abstraction from nature while dreaming before it, and think more of the creation which will result [than of the model]." Bernard was clearer in his verbal formulations; he could quote from Neo-Platonic philosophers ("The idea is the form of things outside those things"); he influenced Gauguin in his use of religious subjects, such as the *Jacob Wrestling with the Angel* and later *The Yellow Christ*. But visually it is Gauguin who takes the decisive steps, his pictures that are revolutionary.

The stylization of these Brittany paintings is evident. Their use of bold outline that calls attention to itself rather than to what it represents, of flat individual forms that avoid foreshortening, of patterned rather than perspective space, are easily recognizable reactions against Impressionism. Gauguin's love of line, his moral revulsion against modeling because its vagueness permits deceit, are all well known. But with eyes accustomed to the further innovations of his successors, we perhaps tend to forget how bold

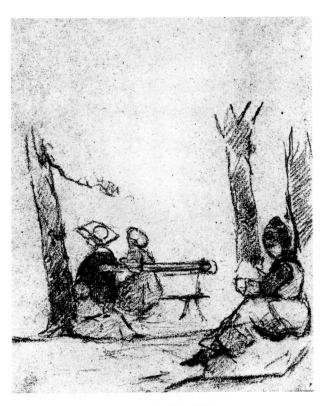

SEATED FIGURES. 1884. Pencil, 10¼ x 7⅞"
Collection Miss Selma Erving, Hartford, Conn.

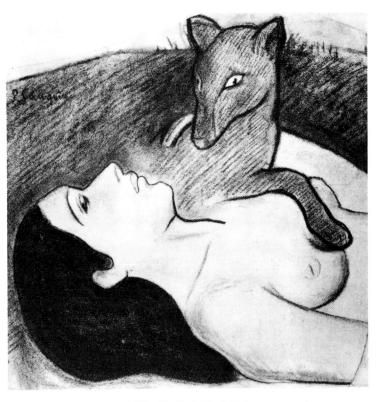

WOMAN WITH A FOX. c. 1891. Chalk, 12¼ x 12¾"
Collection Mr. and Mrs. Leigh B. Block, Chicago

BRETON GIRLS DANCING. c. 1888. Pastel, 9½ x 16⅛". *Stedelijk Museum, Amsterdam*

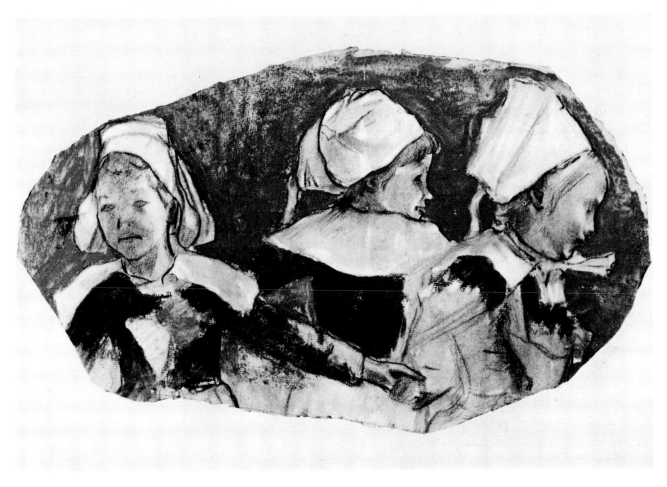

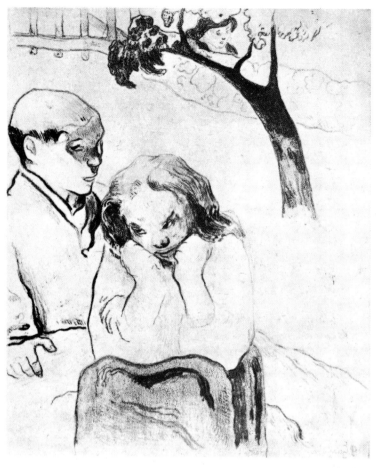

HUMAN MISERIES. 1889. Lithograph, 11¼ x 9"

Gauguin's colors were for the time, not merely in the distance of their departure from nature observed, but also in the (for the period) clashing harmonies he now employed. Given the somber tones of the Breton landscape in which he worked, it is clear that they were indeed the product of an "abstract" imagination. Gauguin later said, "I am not a painter after nature"; it was in Brittany, in the summer of 1888, that this became true.

DURING HIS BRIEF AND TRAGIC STAY with Van Gogh in Arles at the end of 1888 Gauguin's palette hardly changed. The two months in the South, away from the overcast skies of Brittany, produced no interruption in his style. Before and after he continued the search for a "synthesis of form and color while considering only the dominant." He had in a way anticipated much of the brilliance of the Southern sun.

In the "yellow house" in Arles the two men—"The one a volcano, and the other boiling too, but within" —lived at close quarters, painting and arguing. (It goes without saying that Gauguin was in no way the cause of his friend's illness.) But there was little in-

fluence of either painter on the other. Van Gogh's taste was for human drama and modeled form (Daumier and Millet); Gauguin's for cool analysis, flat planes, and outline (Ingres and Degas). "He is romantic and I tend rather toward a primitive state. As to color, he likes the accidents of thickly applied paint . . . and I detest the worked over surface." Apart from a few of Vincent's paintings done during the two months when they were in daily contact which—like the *Arlésienne* (page 31)—show evidences of Gauguin's smooth areas and curving line, each reinforced in the other the consciousness of his own style. Perhaps Van Gogh touched Gauguin with a sense of tragedy; the greater depth of his religious pictures of 1889 suggests it (page 68) as well as his own later comments. But the sober construction and rather thin surface of Gauguin's Arles landscapes seem closer to Cézanne than to Van Gogh's impetuous rendering (page 64).

During the next two years (which began with a sojourn in Paris before returning to Brittany in the spring), Gauguin reached the height of his early style. He was by this time, as Maurice Denis wrote later, "The undisputed master" of a new direction in painting, "whose paradoxical pronouncements were collected and spread . . . Without ever having sought for beauty in the classical sense he almost immediately led us to be preoccupied with it." It was now evident that he and his disciples had reacted against Impressionism, and if the famous exhibition on the walls of the Café Volpini at the Exposition of 1889 carried the title "Impressionists and Synthetists" it was in a desire to join some tradition, however new.

The exhibition (organized by Schuffenecker) was made up of the painters of the "School of Pont-Aven," those men whom Gauguin had gathered around him in Brittany. Among others, Gauguin showed seventeen pictures, Bernard more than twenty, De Monfreid three. Van Gogh refused to exhibit; Toulouse-Lautrec was not admitted to the group. More important than the immediate notoriety it brought, or the derisive laughter of the crowd, was its influence upon a group of young artists, the "Nabis," who had hitherto known of Gauguin's innovations only vaguely. Paul Sérusier, Maurice Denis, Aristide Maillol, Edouard Vuillard (to a lesser extent Bonnard), all were disturbed and excited by this new direction in painting. It played a decisive role in the formation of their style of the succeeding decade. Thus, in a fashion ironic enough to satisfy even him, Paul Gau-

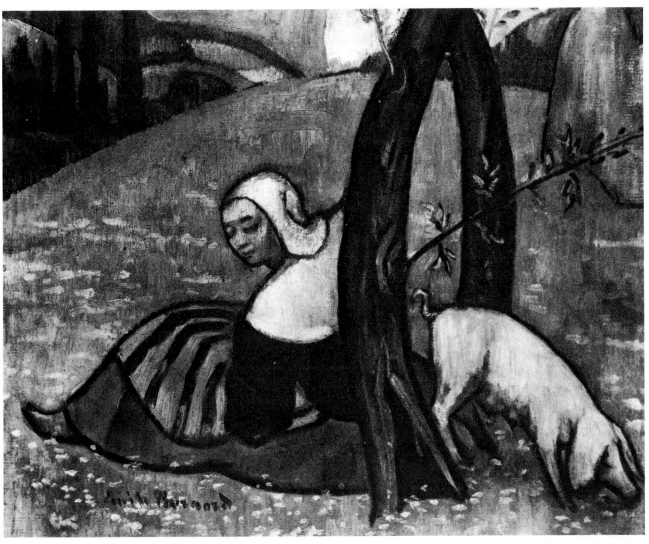

Emile Bernard: SWINEHERD AT PONT-AVEN. 1888. Oil, 19⅞ x 24¾". *Hirschl and Adler Galleries, New York*

guin, while yet unrecognized, was already an "old master."

In Brittany, first again at Pont-Aven, and then at the more secluded Pouldu, Gauguin was in a productive vein. Not a religious man in the ordinary sense, but with a strain of mysticism, he was impressed with the sincerity and wholeheartedness of the Breton peasants' beliefs. If he dreamed of them, and rendered them through his own ideal image of the primitive rather than in their somewhat drab reality (as he had said that the artist must dream before nature) it was a generous and sympathetic dream (page 56). The bite and sarcasm of his pen and tongue, Gauguin (like many another) reserved for those who understood him best. The "little people" of Brittany, who, when they had any contact with his art, disliked it, he saw with a romantic eye; they left his dream of humanity undisturbed. He admired Degas, but found he lacked "a heart that moves. The

tears of a child are something too, though they have no learning."

The same love of the simple and direct may be found in his style. Gauguin mistrusted subtlety, whether in art or in people. He preferred "barbarism" to "civilization" (as he later wrote to Strindberg), and—what seemed to him—the honesty of flat planes and contrasting colors to the subterfuges of modeling by those who did not know how to draw. Paradoxically, however, these simplifications of method and visual appearance brought with them—indeed were designed to suggest—complexities of meaning. The surface of nature no longer being the painter's goal, nature could no longer be the unambiguous model. Representation, which in one sense had ceased to be representation, took on symbolic overtones going far beyond the "corner of nature" that had provided his point of departure. Thus by the time Gauguin came into intimate contact with the Symbolist writers and

29

THE ALYSCAMPS AT ARLES. 1888. Oil, 36¼ x 28¾". *The Louvre, Paris*

(against the advice of that other "symbolist," Redon) to leave, alone, for Tahiti, it was Octave Mirbeau, at the request of Mallarmé, who wrote an article in conjunction with the sale that was to finance the voyage. Mirbeau's words convey to us what the group saw in his painting: "A sad work, for in order to understand it one must have suffered sorrow and the irony of sorrow, which is the threshold of mystery. Sometimes it rises to the height of a mystical act of faith; sometimes it shrinks and grimaces in the frightening gloom of doubt . . . There is in this work a brilliant and savory mixture of barbaric splendor, of Catholic liturgy, of Hindu reverie, of Gothic imagery, of obscure and subtle symbolism; there are sharp realities and sudden flights of poetry, through which M. Gauguin creates an absolutely personal and altogether new art . . ."

GAUGUIN ARRIVED IN TAHITI on June 1, 1891. The move had been long considered. He had even discussed it with Van Gogh during their efforts to set up the studio of the South, to which the "studio of

Van Gogh: THE ALYSCAMPS AT ARLES. 1888. Oil, 36½ x 29" *Collection Mr. and Mrs. Edwin C. Vogel, New York*

poets in the winter of 1890-91 he could understand their language and they could see in his art a parallel to their own methods and purposes.

In this way the savage became a friend of those who, like Verlaine, believed only in the nuance. Through the critic Albert Aurier (a friend of Bernard's) who first introduced him, he eventually came to know the whole literary avant-garde: Stuart Merril, Jean Moréas, and Charles Morice; Mallarmé, of whom he etched a portrait (page 22), Verlaine, and Paul Fort; and the whole group of the new *Mercure de France*. He met too Carrière and Rodin, friends, and in their own way Symbolists. And in this milieu he found sympathy for his art (if not always for his person). He made ironic references to *"cymbalistes"* and *sintaise,* but his double aim of simplicity and mystery was their aim, his love of the exotic and occasional suggestion of the satanic was akin to theirs.

Thus when Gauguin, after having hesitated between Madagascar and Oceania, finally decided

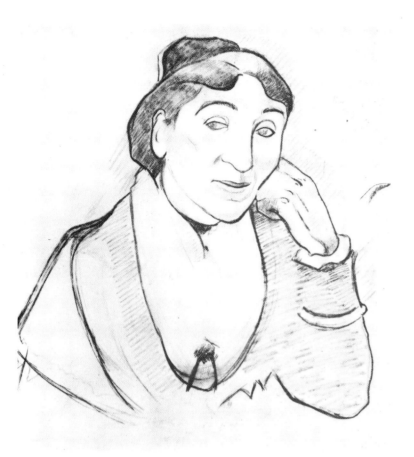

L'ARLÉSIENNE. 1888. Charcoal, 22 x 19"
Collection T. Edward Hanley, Bradford, Pa.

the tropics" was to be a successor. But although he had long envisaged "the Tahitians, happy inhabitants of the unexplored paradises of Oceania [who] know only the sweet sides of life," it took him some time to get familiar enough with his surroundings to paint them. "I have seen so much that I am troubled," he wrote in July. Once in Tahiti, he thought again of Paris, and for some months made sketches for pictures to be completed when he was back in France, much as Delacroix (whose journals Gauguin knew) had filled his North African notebooks for later use. This ambivalence (which shows how truly Gauguin was both attracted and driven into exile) was to remain with him until the end of his life, when he would have been willing to risk destroying the legend that had grown around him in order to pass through Paris (unknown to the public) on the way to Spain. And there was another ambivalence which persisted. Having come all this way to find the proper surroundings for his art ("Down there," he had written to Redon, "I shall cultivate it [my art] for itself alone in its primitive and savage condition. For that I need calm"), he still could say, "I am content to search within myself, and not in nature, to

learn to draw a little . . ." How ironic to have come so far, and still to know that "My artistic center is in my brain, and nowhere else, and I am strong because . . . I do what is within me."

Gauguin's style of painting changed little in the twelve years left to him. Now in Tahiti, the exotic replaced the provincial within his image of the primitive, and he often repeated the portrayal of simple religious faith that had so attracted him in Brittany. He carried that image with him, and his surroundings provided the context rather than the content of his dream. Sometimes that dream is of a savage Eve "still able to walk naked, without indecency, preserving all her animal beauty," but an Eve who has "an ironical smile upon her lips and . . . looks at us enigmatically." This is the Eve whom Strindberg could not understand because—as Gauguin put it—"of the civilization from which you suffer." Sometimes he paints Eve's own dream, or her dream as he imagined it, the legends and the myths of a primitive religion seen through Symbolist eyes, as in the *Spirit of the Dead Watching* (page 88) or

Van Gogh: L'ARLÉSIENNE. 1888. Oil, 36 x 29"
Metropolitan Museum of Art, New York

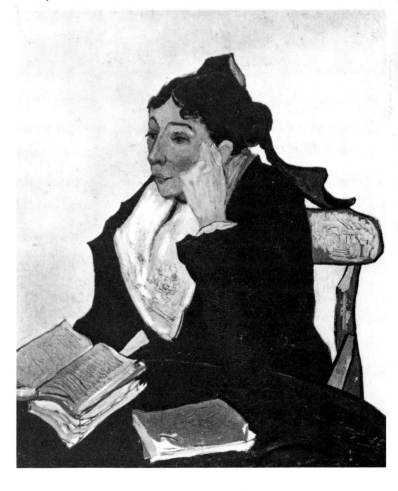

Emile Bernard: APPLE PICKERS. 1890. Oil, 21¾ x 18″
Collection Mr. and Mrs. Lee Eastman, New York

The Moon and the Earth (page 96). Occasionally he looked about him and painted what he saw.

It is characteristic of his process of creation that the formal pattern of his Tahitian pictures should so often have been suggested to him by other works of art. For all that Gauguin was an innovator, he had a strong sense of tradition, and though he had decided opinions he was also an eclectic. The patterns and poses of Javanese and Egyptian friezes, the religious positions of the Indian Buddha, the stance and gesture of Parthenon figures, whose recollection or whose photographs he had brought with him from Paris, played recurring roles in his Oceanic paintings. He drew on them, as he drew on Monet, and Puvis de Chavannes, and the Italian "primitives." As he said, he was not, basically, a painter from nature: "everything happens in my wild imagination."

In the course of the dozen years between Gauguin's first arrival in Tahiti and his death in the Marquesas, his style did soften. (The eighteen months spent in France did not materially affect his evolution.) He still posed figures with a minimum of foreshortening, but their forms were rounded and more modeled. The heavy, drawn outline of the Breton paintings disappears, although color areas still meet in sharp edges. At the same time contours themselves become more sinuous and more intricate; bent forms meet in angles, and undergo sudden reversals of direction. With certain exceptions (like *Le Repos,* page 108), he tends to compose in frieze-like arrangements, and to employ less frequently the angular perspective and the view from above of the earlier Breton canvases. The flat space of the pictures of the eighties (like the *Breton Peasant Women,* page 56) is now less pronounced; the arrangement is in overlapping planes, frontal to the picture-plane, that, much like the sculptured bas-reliefs by which he was so much influenced in details, suggest more space than is actually rendered. (This is the principle of such pictures as the *Nave Nave Mahana,* page 102; or *Where Do We Come From?,* page 9). The spectator is excluded from most of these pictures, with their figures so often caught in the arrested, rhythmic motion of a sort of hieratic dance, a pantomime full of the mystery and enigma

THE BLACK VIRGIN. 1889-90. Ceramic, 19″ high
Collection Harry Guggenheim, New York

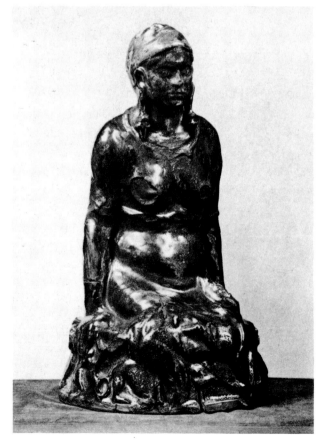

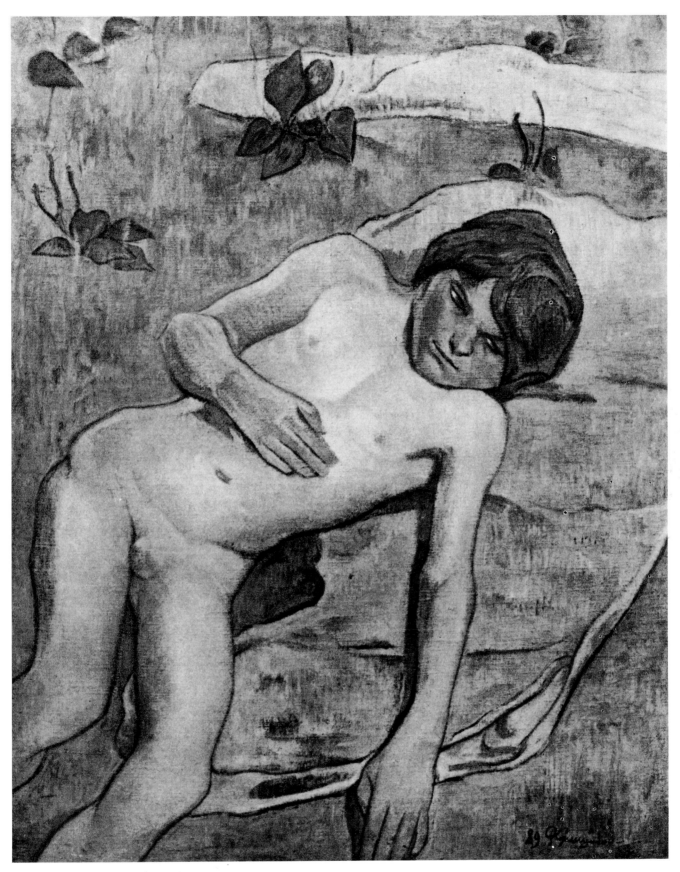

BRETON BOY. 1889. Oil, 36½ x 29″. *Wildenstein & Co., New York*

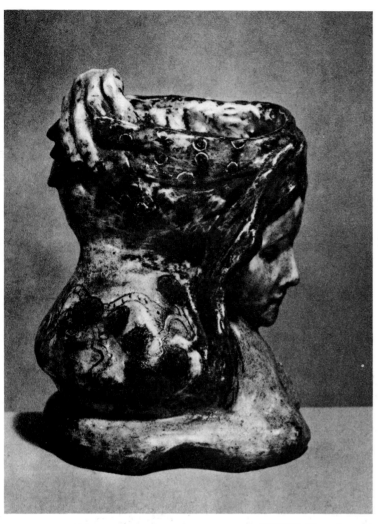

PORTRAIT OF MME. SCHUFFENECKER. 1888-89. Ceramic vase
Collection Emery Reves

ture), they are also more graceful, painted with a feeling for the nuances of both color and surface.

THERE IS AN INTIMATE CONNECTION between Gauguin's strong reaction against Impressionism and his subsequent influence. The analytic approach of Cézanne and Seurat bore its fruit in Cubism and geometric abstraction. Rooted in naturalistic observation, it nevertheless by a kind of logical extremism led toward its opposite. And despite the Fauves, who owed so much to Gauguin, for the first quarter of our century this direction appeared dominant. Gauguin's importance took longer to understand, but it was as essential and as lasting.

Some aspects of his role are so to speak external; they are to be seen in the visual appearance of subsequent paintings. In his emphasis upon line ("Drawing, that's all there is") and flat plane, he anticipates

HEAD OF A GIRL. C. 1889. Ceramic, 7⅞″ high

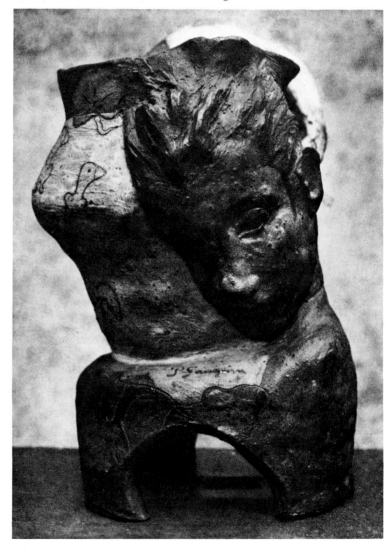

so dear to Gauguin's heart. It is as though Gauguin, having come so far to immerse himself in this new, yet ancient existence, were still the observer of a spectacle outside him. (Even the *Nativity*, page 106, is composed like an Italian predella.) Thus Gauguin (like Seurat and Cézanne, but in his own way), in reaction to the Impressionist "corner of nature," restores to the painting the independence of a self-contained microcosm.

The range of color too is richer and more varied, sometimes light (as in the *Nativity*), sometimes bright (as in *Ta Matete*, page 84), more often darker than the palette of his earlier northern works. It is a paradoxical proof of Gauguin's inventive freedom that the Brittany pictures are brighter, have in them less feeling of water-laden atmosphere than the South Sea canvases painted in the brilliance of the southern sun. On the whole these later pictures are freer and more assured, less programmatic in conception. If they are less bold (and so less influential in the fu-

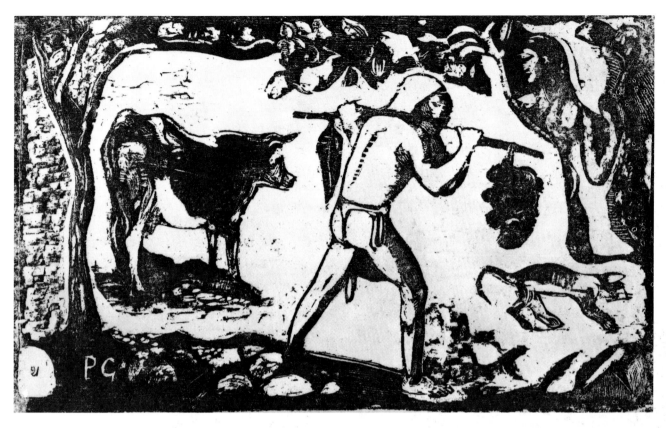

BEARER OF BANANAS. c. 1897. Woodcut, 6⅜ x 11¼″. *National Gallery of Art, Washington, D. C. (Lessing Rosenwald Collection)*

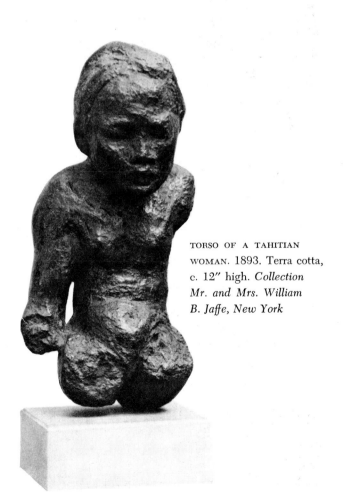

TORSO OF A TAHITIAN
WOMAN. 1893. Terra cotta,
c. 12″ high. *Collection
Mr. and Mrs. William
B. Jaffe, New York*

TWO HEADS. Monotype, 18⅛ x 13½″. *National Gallery of Art
Washington, D. C. (Lessing Rosenwald Collection)*

35

JOSEPH AND POTIPHAR'S WIFE. 1896. Oil, 34¾ x 46¼". *Museum of São Paolo, Brazil. Photograph courtesy Wildenstein & Co., New York*

much of the *art nouveau* that spread across Europe and the United States in the nineties. He is not alone in this; anticipations of *art nouveau* can be found in Seurat and Van Gogh. But he was even more conscious of silhouettes than they, and his curvilinear stylizations that start in the eighties and run through the Tahiti pictures have a rhythmic decorative strength that was important for the future. They were a direct source of some of the earliest (and best) work of Bonnard and Vuillard, as well as the other "Nabis," and thus were both a direct and an indirect influence in the formation of the Fauve style. Besides, Gauguin's palette of non-primary hues—the pinks and mauves and oranges and violets—used in "clashing" juxtaposition, anticipates Matisse and others of his generation. Like them, he bases his color harmonies upon the juxtaposition of allied, rather than contrasting colors. Gauguin's simplification of outline and reduction of modeling, and the deliberate broadness and crude-

Pierre Paul Prud'hon: JOSEPH AND POTIPHAR'S WIFE. c. 1793. Drawing

36

STILL LIFE WITH "HOPE." 1901. Oil. *Private collection*

ness of his wood-block prints, which enlist the accidents of the material in their finished effect, were fundamental in the formation of Munch and the German Expressionists. And from him finally (compare *The Day of the God*, page 100) stem the fluid forms and abstract organic shapes of Miró and Arp and the younger men in their tradition right down to the present day. Thus the appearance of Gauguin's painting anticipates, and influences, much of the appearance of work done long after his.

In an even more essential way, however, Gauguin's attitude toward his art, his method of creation and its implications, mark a break with the past and the beginning of a modern tradition. It lies not simply in his rejection of Impressionism, but in the way this was carried out. He found the Impressionists too

BELOW: Puvis de Chavannes: HOPE. 1872. Oil, 27½ x 31⅛"
The Louvre, Paris

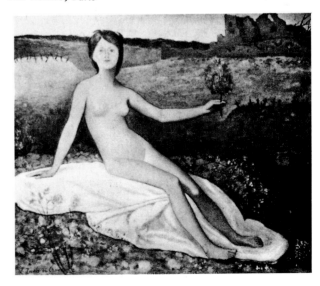

literal, so bound by observation that they "neglected the mysterious centers of thought." "Art is an abstraction; derive this abstraction from nature while dreaming before it." But Gauguin had no desire to return to the traditional literary allegories of Puvis de Chavannes, which start from "an *a priori* abstract idea," and are executed deliberately, "sketch after nature, preparatory cartoon, etc.," and in which each figure has an accepted unambiguous meaning. This was just another kind of literalism.

Gauguin from the very start was more interested in "suggestion than in description." As early as 1885, while his style was still Impressionist, he had explained that Raphael's quality lay in his having formulated his sensation before his thought, something the academics had never realized. But neither must art serve nature, and the superiority of primi-

LE PÈRE PAILLARD. 1892. Wood, 27″ high
Chester Dale Collection, New York

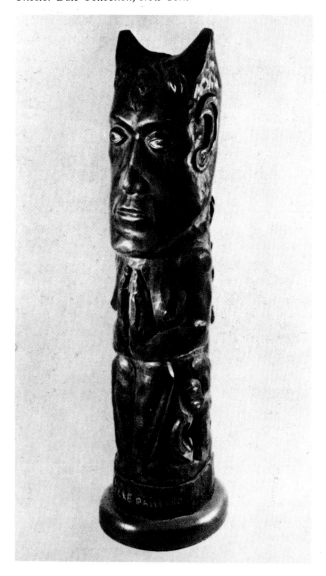

YOUNG MARQUESAN WOMAN. Photograph taken in 1901 in Gauguin's studio on the island of Atuana, and sent to Daniel de Monfreid. On the wall, reproductions of pictures by Puvis de Chavannes, Degas, and Holbein. *Collection Mme. A. Joly-Ségalen, Bourg-la-Reine, France*

tive art, "which proceeds from the spirit and makes use of nature," lay in having avoided the error of naturalism. In various forms this return to the primitive is a recurrent theme in Gauguin's thought. Not only is he himself a savage fleeing civilization ("Civilization from which you suffer. Barbarism which is for me a rejuvenation"), not only is he the "Indian" who has suppressed the sensitive side of his nature— "a child and a savage"—but he has a constant preference for the simple in art: "The great error is the Greek." Egypt, Persia, Cambodia, the Japanese woodcut, the *images d'Epinal*, the flat surface and the bold line, these are what he prefers. He wants to reduce his means. "Seek the simplest form," he says as early as 1885, a theme again repeated in his defense of *Where Do We Come From?* in 1899, where he has wished "to translate [his] dream without recourse to literary means, and with all the simplicity the medium permits." It reappears in 1901, when he writes to Charles Morice, "Are the forms rudimentary? They must be. Is the execution much too simple? It has to be."

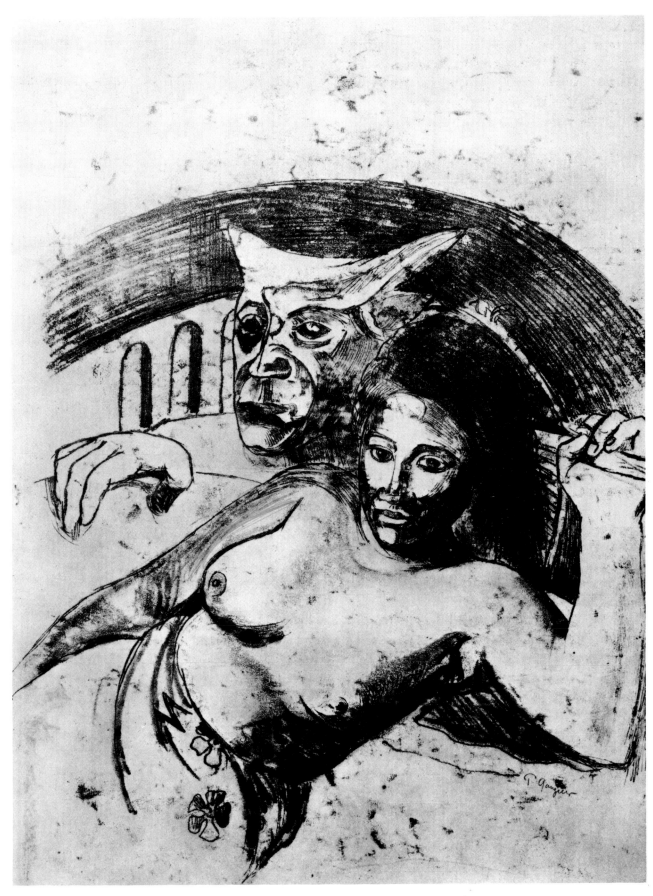

GIRL WITH DEVIL. 1895-1903. Monotype. *Private collection, France*

ORIGINAL PRINTING BLOCK carved for MAHANA ATUA. c. 1895
National Gallery of Art, Washington, D. C.
(Lessing Rosenwald Collection)

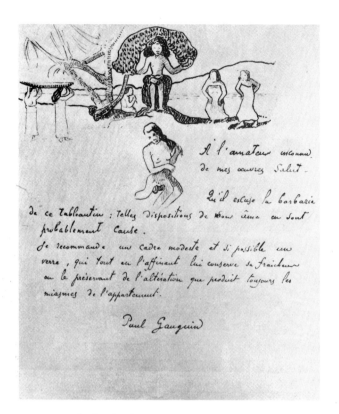

LETTER, with sketch of MAHANA ATUA. Pen and ink, 10 x 7½″
Collection Mr. and Mrs. Alex M. Lewyt, New York

Where then are the forms discovered, where does the painter find his style? Not in nature, as we have seen. "I am not a painter from nature—now [1900] less than ever. Everything takes place in my wild imagination." Already in 1888 Gauguin was at least partially painting without recourse to the model, and in Tahiti even his still lifes were finished in this fashion. It was within himself that he searched, not in his surroundings; it was his "wild imagination," not nature, that gave him his themes and his forms: "My artistic center is in my brain."

Thus Gauguin opposes both the literal and the literary. In their stead he proposes "mystery," "enigma," "suggestion." "Painting should seek suggestion more than description, as indeed music does," he writes to De Monfreid in 1901. Too great a technical perfection robs the canvas of its power to stimulate the imagination. "Does not promise evoke mystery, since our natures do not include the absolute?" The sense of a picture lies not in its title or its subject, but in those visual elements of which it is composed; its true meaning, related only indirectly to representation, is found in the arrangement of its lines and shapes and colors whose "musical" qualities have the power of suggestion. "When will people understand that the execution, the drawing and the color (the

THE FOOD OF THE GODS (MAHANA ATUA). c. 1895. Woodcut, 7⅛ x 7⅞″
National Gallery of Art, Washington (Lessing Rosenwald Collection)

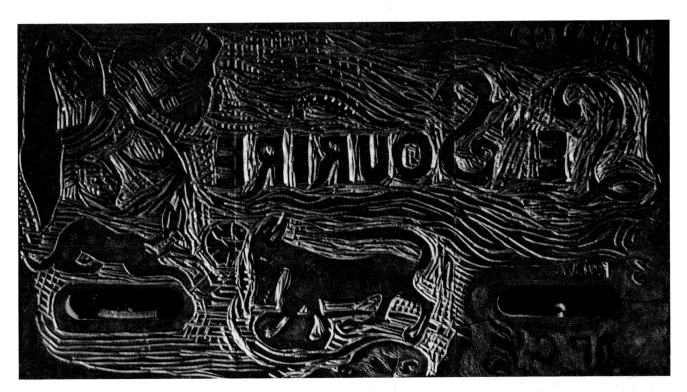

ORIGINAL PRINTING BLOCK carved for LE SOURIRE. *National Gallery of Art, Washington, D. C. (Lessing Rosenwald Collection)*

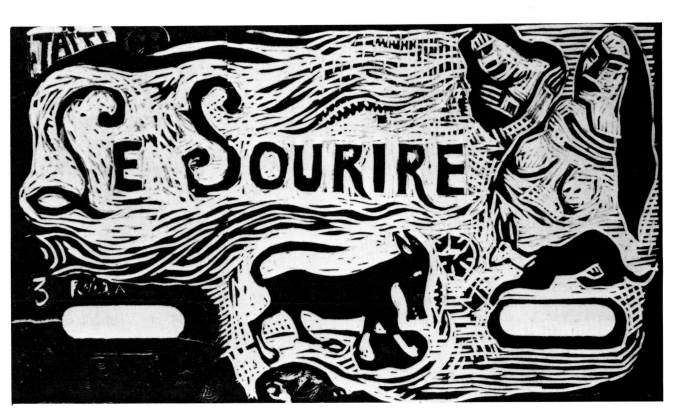

THE SMILE (LE SOURIRE). 1899. Woodcut, 4-1/16 x 7-3/16″

41

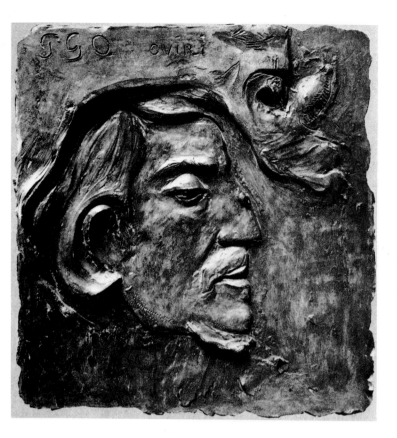

SELF-PORTRAIT. c. 1891. Plaster bas relief.
Formerly collection A. Schuffenecker, Paris

its increasing reliance on the means of pure painting; its willingness to allow the work to grow under the hand of the artist, while the artist finds inspiration in his unfolding creation. From Tahiti, Gauguin quoted Mallarmé with approval: "The essence of a work, unsubstantial and of a higher order, lies precisely in 'what is not expressed; it is the implicit result of the lines without color or words; it has no material being.'"

This is the attitude of our own day. Gauguin was aware that it was new and looked to the future. "You have known for a long time," he explained to De Monfreid in a letter of October, 1902, "what it has been my purpose to vindicate: the right to dare anything." But he was also aware of its roots in the past, of Delacroix, and of the romantic tradition. It was Baudelaire who wrote: "What is pure art according to the modern concept? It is the creation of a suggestive magic which simultaneously contains object and subject, the world outside the artist, and the artist himself."

SELF-PORTRAIT. c. 1902. Pencil
Collection Mme. A. Joly-Ségalen, Bourg-la-Reine, France

style) must be in accord with the poem? My nudes are chaste without clothes. To what can this be attributed if not to certain forms and colors which remove [them] from reality?" Thus throughout his life, while developing nuance and subtlety, he was still saying, and still painting the insight with which he had begun in the eighties: "Art is an abstraction."

But this abstraction which translates feeling is not to be developed by logical means. The artist has little conscious control over the essence of his work whose formulation has nothing to do with reason. Throughout his letters and notebooks, but above all in his discussions of his great testamentary panel, *Where Do We Come From?* Gauguin emphasizes the subconscious sources of inspiration. He "painted and dreamed at the same time," allowing his dream to form within him, calling upon his whole past sensation and emotion until "having reached the propitious moment everything becomes concentrated and the execution [of the work] is rapid." "The cold calculations of reason have not presided at this birth, for who knows when, in the depths of the artist's soul, the work was begun—unconsciously perhaps."

And so Gauguin anticipates much that is basic to modern painting: its predominant anti-naturalism,

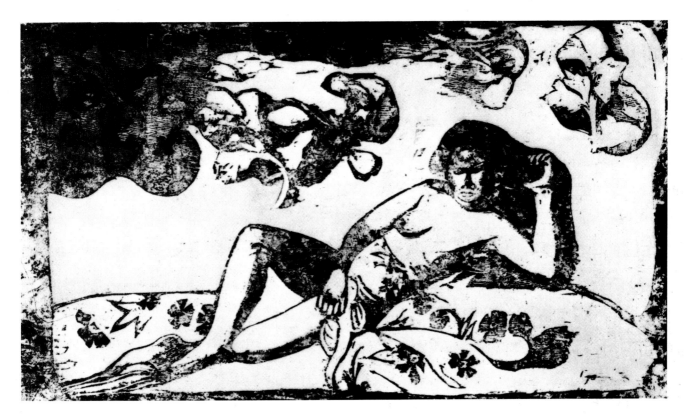

WOMAN OF A ROYAL RACE (TE ARII VAHINÉ). c. 1896. Woodcut, 6⅞ x 11-1/16″. *Brooklyn Museum, New York*

CHRONOLOGY

1848

Paul Gauguin born June 7, at 56 Rue Notre Dame de Lorette, Paris. Clovis Gauguin, his father, who came from Orléans, was a journalist; his mother, Aline Chazal (daughter of Florine Tristan, well-known Saint-Simonian writer) came from a Spanish family which had settled in Peru.

1851

After the seizure of power by Napoleon III, the family leaves for Peru. Gauguin's father dies during the voyage and is buried at Port-Famine, in the Strait of Magellan. Gauguin, his mother and sister Marie spend four years in Lima.

1855

Paul, his mother and sister return to France, and live with his uncle, Isidore Gauguin, at 7 Rue Endelle, in Orléans.

1859

Gauguin enters the Petit Seminaire, a boarding school at Orléans.

1865

He enters the merchant marine as a pilot's apprentice (as had Baudelaire and Monet). As such he makes his first trip on the *Luzzitano* from Le Havre to Rio de Janeiro, and becomes conscious of exotic countries.

1868

He enlists in the navy in Le Havre February 26. Embarks on the cruiser *Jérome Napoleon.*

1871

His term of service expires in April. (While he is at sea his mother has died, and his sister has married a Chilean merchant, Juan Uribe.)

On April 23, through the kind offices of Gustave Arosa, a banker whom his mother had asked to look after him, he enters the employ of the firm of Bertin, stockbrokers, in the Rue Laffitte (a street in which there are also art galleries). Here he meets Emile Schuffenecker.

1872

He does well with the firm, his social and financial situation is excellent.

1873

On November 22 he marries Mette Sophie Gad, a girl from Copenhagen, in the City Hall of the ninth *arrondissement;* the religious ceremony is celebrated in the Lutheran Church of the Rue Chauchat.

1874-76

Gauguin begins to paint on Sundays; studies from the model at the Colarossi Academy; meets Pissarro, and through him the other Impressionists; starts to form a collection of their pictures.

In September, 1874, his son Emil is born; in December, 1876, his daughter, Aline.

1876

Exhibits a landscape at the official Salon.

1877

Living in the Rue des Fourneaux.

1879

His son Clovis is born in May. During the summer Gauguin works with Pissarro at Pontoise.

1880

Rents an atelier at 8 Rue Carcel, in the Vaugirard quarter, where he stays until 1883.

Exhibits in the fifth exhibition of the Impressionist group, held in April in the Rue des Pyramides.

1881

Shows in the sixth Impressionist exhibition, held at Nadar's in the Boulevard des Capucines.

His *Study of a Nude* is praised by Huysmans. Spends the summer holidays in Pontoise with Pissarro, through whom he meets Cézanne.

1882

Participates in seventh Impressionist exhibition, held in March in the Rue St. Honoré.

1883

In January, without warning to family or friends, Gauguin quits his job. "From now on I will paint every day." During June, works with Pissarro in Osny. In November, looks for a house in Rouen. Pola is born in December.

1884

In January, Gauguin, his wife and children move to Rouen. In November, the whole family moves to Copenhagen, going by sea.

1885

Gauguin works as the Scandinavian representative of the French firm of Dillies & Cie., makers of tarpaulins and canvas blinds.

Quarrels with his wife, her family and friends.

His Copenhagen exhibition (in April?) closes after five days.

In June, returns to Paris with his son Clovis, lives in the Impasse Frémin. At end of September is in Dieppe, then departs on a three-weeks journey to London.

In October, moves to the Rue Cail.

1886

In April, with Clovis sick, he is so poor he works as a bill poster for five francs a day.

Participates in the eighth (and last) Impressionist group exhibition, May and June, in the Rue Laffitte.

At the end of June, after putting Clovis in a pension in the suburb of Antony, he goes to Pont-Aven in Brittany, stays at the pension Gloanec. There, in August, is the first, brief, and not very cordial, meeting with Emile Bernard.

Returns to Paris in November, meets Van Gogh in Montmartre. Sick and in the hospital during December. Now avoids Pissarro, meets Degas at the Café de la Nouvelle Athènes.

1887

On April 10, with the painter Charles Laval, Gauguin embarks at St. Nazaire for Panama ("I go to Panama to live as a savage"), where his brother-in-law, Juan Uribe, is in business, hoping to live for nothing on a neighboring island. Works as a laborer on the Canal for a month. When fired, goes to Martinique in June. Falls sick, and in the fall earns his return passage to France as a sailor. Back in Paris at the end of November, he goes to live at the house of Emile Schuffenecker, in the Rue Boulard. Hopes to earn a living making ceramics with Chaplet, who, however, retires.

1888

February to October, Gauguin's second stay in Pont-Aven.

In August, the second, and fruitful meeting with Emile Bernard (who is in Pont-Aven with his mother and his sister Madeleine). Out of their discussions is born "synthetism," and the painting of the first religious pictures.

In the fall (October?), thanks to the enthusiasm of Theo van Gogh, Gauguin has his first one-man show at Boussod and Valadon, Boulevard Montmartre; it includes ceramics as well as Brittany and Martinique paintings.

At the beginning of October, Paul Sérusier paints the *Talisman* under Gauguin's direction; on his return to Paris he shows it to his "Nabis" friends (Bonnard, Vuillard, etc.) as the demonstration of the new anti-Impressionist theories.

Gauguin arrives in Arles on October 20 (his fare paid by Theo), to join Vincent van Gogh, with whom he stays until the tragic events of December 24. The next day, Gauguin returns to Paris.

1889

Brief stay with Emile Schuffenecker, before renting

an atelier in the Avenue Montsouris, where he stays until April.

Exhibits with the Salon des XX in Brussels.

Visits the Exposition Universelle in Paris; enthusiastic about the Javanese village.

Returns to Pont-Aven in April. Schuffenecker arranges an exhibition of the Impressionist and Synthetist Group at the Café des Arts (Café Volpini) in the Champ de Mars which opens in the late spring (early June?); a *succès de scandale* and laughter, with no sales. Gauguin goes briefly to Paris to help with this.

In October, finding Pont-Aven too crowded with painters and vacationers, he, with Paul Sérusier, who had joined him the previous month, moves to Le Pouldu.

Included in a Copenhagen exhibition of "French and Nordic Impressionists."

1890

Back in Paris in late January, again briefly at Schuffenecker's. Begins to think of going to Madagascar to found the "studio of the tropics." Tries to persuade Emile Bernard and Schuffenecker to accompany him.

Returns to Le Pouldu in June, where he stays (joined at different times, by De Haan, Laval, Sérusier, and Filiger) until he returns to Paris in December. Gradually, on the advice of Mme. Redon, gives up Madagascar for Tahiti, where he feels life will be easier and cheaper.

In November, returns to Paris.

1891

In January, after being put out by Schuffenecker, lives in the Rue Delambre, then in the Rue de la Grande Chaumière. Through Albert Aurier, meets the Mercure de France group at the Café Francois Premier. Frequents the Symbolist group at their Monday evening meetings at the Café Voltaire.

Urged by Pissarro and Mallarmé, Octave Mirbeau does an article about Gauguin, which appears in February in the *Echo de Paris*.

In March, Aurier's article on Gauguin is published by the *Mercure de France*.

On February 23, in order to raise money for his voyage, Gauguin auctions thirty of his pictures at the Hotel Drouot. The total price is under 10,000 francs. (A joint benefit, for Gauguin and Paul Verlaine, held later at the *Théâtre d'Art* of Paul Fort, future brother-in-law of Emile Bernard, loses money.)

Leaves the next day on a quick trip to Copenhagen, where he arrives February 26. Back in Paris by

March 20. On March 23, there is a farewell banquet in Gauguin's honor at the Café Voltaire. Mallarmé presides, some thirty artists and writers are present, among them Redon, Carrière, Alfred Valette, Aurier, Jean Moreás, and Saint-Paul Roux.

On April 4, Gauguin sails from Marseilles for Tahiti, by way of Melbourne, Sidney, and Noumea. Arrives at Papeete on June 1. Soon leaves to live among the natives, 25 miles to the south, in the district of Mataiea. Tehura is his native *vahiné*.

In November, he receives his first letter from France, from Paul Sérusier.

1892

Works on the first draft of *Noa Noa;* is painting very busily.

In March, is sick and at the hospital.

In June, he asks the governor to repatriate him, but after selling a picture for 400 francs, and obtaining the promise (never fulfilled) of an order for a portrait, he changes his mind.

Works included in a group exhibition of modern painting in Copenhagen.

In September there is the first showing of a Tahitian painting in Paris.

Writes the *Cahier for Aline*.

1893

In June (?) having received 700 francs from his wife (for pictures sold by her?), Gauguin leaves for France by way of Noumea and Sidney. Arrives in Marseilles on August 4, with four francs in his pocket; there, *poste restante*, he finds 250 francs (lent by Sérusier, sent by Monfreid), for the return to Paris, where he is on August 6. At the end of the month goes to Orléans for the funeral of his uncle.

In September, rents an atelier, Rue de la Grande Chaumière; then moves to the Rue Vercingétorix, where he lives with Annah the Javanaise; decorates atelier with exotic objects; holds weekly receptions.

At Degas' urging Durand-Ruel consents to give Gauguin a show. It opens on November 4, with 38 Tahitian and 6 Brittany canvases, as well as 2 sculptures; Charles Morice writes the catalogue preface. Sells 11 paintings, barely covering costs; but attracts many curious visitors.

At the end of December, he receives his share of his uncle's estate; sends nothing to his wife in Denmark.

1894

Visits Bruges in January, especially to see Memling's paintings. Makes a short trip to Copenhagen to see

his wife and children for what turns out to be the last time.

In Brittany (Pont-Aven and Le Pouldu) from April to December.

In May, during a brawl with sailors in Concarneau (they had made remarks about Annah) he breaks his ankle, is in pain for several weeks. Already considers returning to the South Seas, this time, if possible, with friends.

Upon his return to Paris, he finds that Annah has emptied his studio of everything but his paintings, and disappeared.

1895

Decides to return to Tahiti.

February 18, there is an auction of Gauguin's paintings at the Hotel Drouot. As a preface, an exchange of letters with August Strindberg. The sale nets only a few hundred francs, he has to buy back many paintings.

Sails in March, arrives in Tahiti in July.

Finding Papeete even more Europeanized, he again thinks of going to the Marquesas, but instead builds a large house in the native style on the west coast in the district of Pounoaouia.

1896

Solitude, physical suffering, and despair, reaching a sort of climax in October. By November is feeling better and working more. Pahura is his *vahiné*.

1897

Again in the hospital.

Learns (in May?) of the death of his daughter Aline. In August, again not having received any letters from his children written for his birthday, and still greatly affected by his daughter's death, breaks off correspondence with his wife.

1898

On February 11 attempts suicide, after having painted *Where Do We Come From?* . . . as a testamentary picture. In the hospital.

In April, takes a clerical job in the Bureau of Public Works, which continues at least through March, 1899. In August (?) goes to Papeete.

At the end of the year begins to sell pictures to Vollard, at prices he considers much too low.

Returns to his house in the hills.

1899

Trouble with the local authorities, whom he accuses of persecuting him. Publishes *Les Guêpes* (*The Wasps*) and *Le Sourire* (*The Smile*), satirical journals, in which he defends the natives against the authorities.

1900

Sick and not painting most of the year (March to November?). No money to pay for treatment.

Finally, at the end of December, does go to the hospital.

Contract with Vollard.

1901

Leaves the hospital in February, "not entirely cured."

In April has influenza. He plans to sell his house and "install myself in an island of the Marquesas, where life is easy and very cheap." Counts on being able to live on his Vollard contract.

In August he moves to Atuana, on the island of Dominique (Hiva-Oa), in the Marquesas group.

Is still not well of his eczema.

1902

The year passes in comparative quiet and hard work.

In August, he is so sick with eczema and a bad heart that he thinks of returning to Paris to be cured. Daniel de Monfreid dissuades him, saying it will destroy his legend.

Writes *Avant et Après* (Intimate Journals) in January and February.

1903

A cyclone hits the islands in February.

In April he is condemned to three months imprisonment for protesting the authorities' scandalous treatment of the natives. Plans to go to Tahiti to appeal.

Writes to his neighbor, Pasteur Vernier, ". . . I am ill and can no longer walk."

On May 8, Paul Gauguin dies.

COLORPLATES

Painted in 1880

STUDY OF THE NUDE

44⅞ x 31⅛" (114 x 79 cm.)

Ny Carlsberg Glyptotek, Copenhagen

"I AM NOT A PAINTER FROM NATURE," said Gauguin on many different occasions. But that was much later, when he had found his own imaginative style. In this canvas, done when he was still a "Sunday painter," he surely is still a naturalist, not casually or lightly, with an eye merely to surface effects, but minutely and conscientiously, with a painstaking care. It is this insistence upon truth of detail, this rendering of a "corner of nature" seen *without* temperament that dominates the picture. Evident above all in the nude, it is also present in the rendering of the texture and variations of the surfaces that surround her voluminous figure: the feel as well as the color of the linen hanging at the top edge, the wall behind, the material upon which she sews. Indeed the straightforward truth of vision (one kind of vision) is so strong that it makes one forget the conventionalities, even banalities (not surprising in one so recently become a painter, and not a full-time one at that) of the setting and the composition: the drapery (reminiscent of certain harmonies of Delacroix) and guitar to close the corner space, the cushion on the bed, the indeterminate distance of the background wall.

It was this note of uncompromising honesty that the novelist Huysmans had in mind when, in 1881, he wrote of this picture, "I do not hesitate to declare that, among contemporary painters who have done nudes, none has achieved such a forceful note of reality, and I do not except Courbet." Huysmans (still a naturalist at this period) might have said that where Courbet struck the tone of Balzac, Gauguin strikes that of Zola. But in this picture only—for his realism was destined to be short-lived.

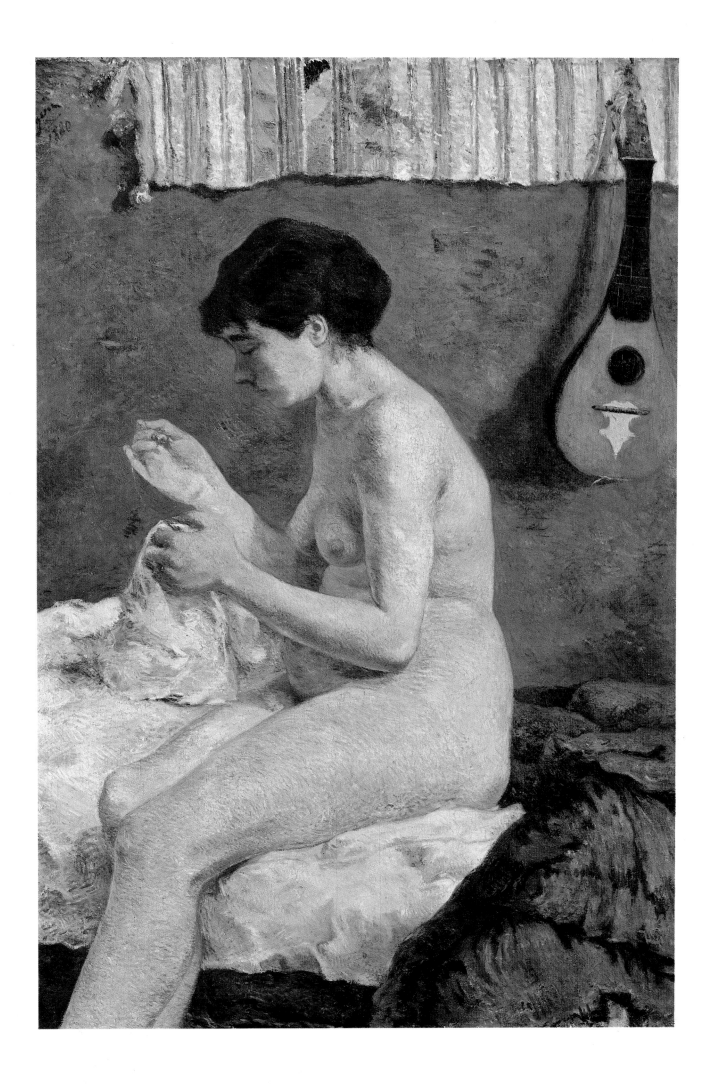

Painted in 1883

GARDEN IN THE SNOW

23⅝ x 19⅝" (60 x 50 cm.)

Ny Carlsberg Glyptotek, Copenhagen

GAUGUIN'S DEVELOPMENT AS A PAINTER (like his manner as a man) seems sudden and brusque. He began late, and skipped the normal student years; the development of his own style out of Impressionism came suddenly and all at once. But the years between, during which he served his apprenticeship as a professional and absorbed the atmosphere and understanding of the styles around him, were comparatively long. He was fortunate in not having to unlearn an academic manner and thus being able to step immediately into the progressive esthetic of his time.

But a picture such as this, painted at about the date (January, 1883) he gave up his business career to become a full-time artist, shows how thoroughly he absorbed Impressionism. The cut off view, the close foreground, coming out and underfoot toward the spectator, the broad brush strokes, the overlaid layers of paint, all these bespeak Impressionism. Especially characteristic of the Impressionism of this period (differing from that of the seventies) is the close (rather than the earlier contrasting) color harmony and the more subdued force. But the scene is somewhat more desolate than those the Impressionists usually paint. It is empty and somehow abandoned, and one is tempted to imagine that this is a reflection of Gauguin's mood, a foreboding of the ever-increasing loneliness that was to haunt him for the remainder of his life.

50

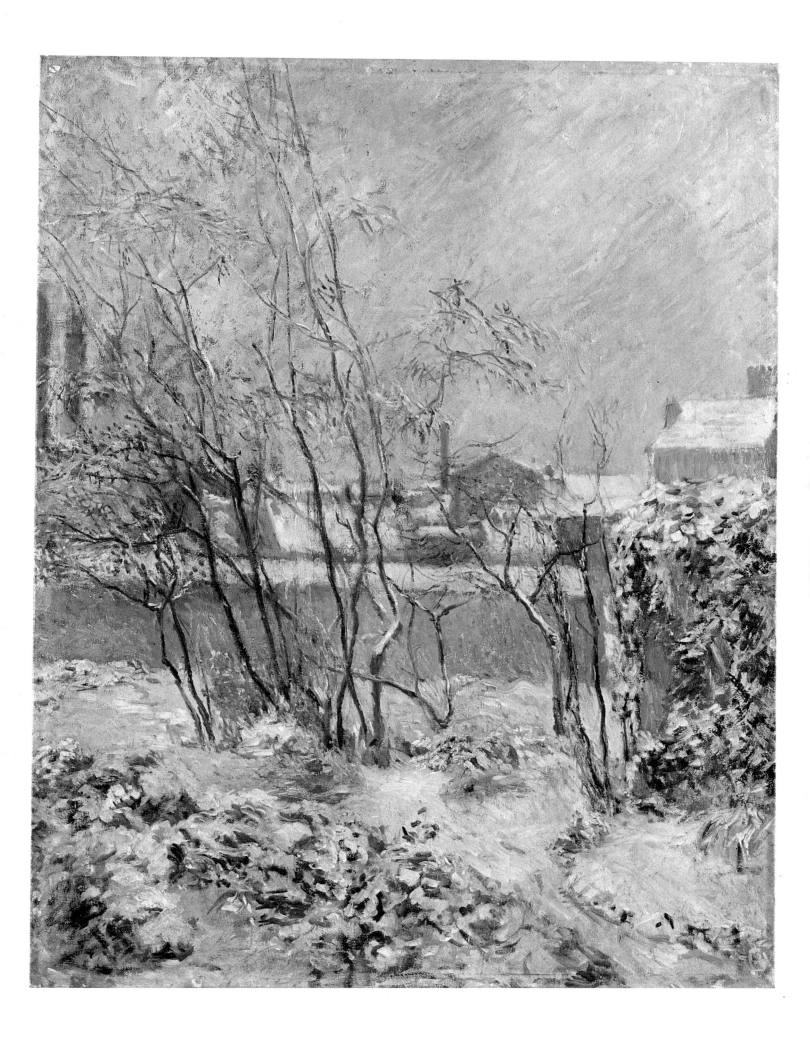

Painted in 1886

SEASCAPE IN BRITTANY

29½ x 44" (75 x 112 cm.)

Private collection, Gladwyne, Pennsylvania

IN JUNE, 1886, GAUGUIN EXHIBITED in the last group exhibition of the Impressionists. At the end of the month, after arranging for his son Clovis to stay at a boarding school in the south Paris suburb of Antony, he left on his first trip to Pont-Aven in Brittany, where he stayed until the middle of November. This picture was painted on the coast near the mouth of the Aven River.

Monet did not take part in this last of the Impressionist exhibitions, among other reasons because he did not like either Gauguin or his art. But it is clear how much Gauguin's painting owes to the older master in subject, in surface, in approach. During 1886 Monet worked both at Etretat on the Norman coast, rendering the effects of the sun on the white chalk cliffs, and at Belle-Isle, off Brittany, where the rocks are darker. Gauguin's painting has more contrast within it than Monet's atmospheric studies, it is somber instead of bright; by including a figure and animals he increases the scale of the scene and gives it a touch of genre. Characteristically, his conception has lost something of the Impressionist esthetic detachment and gained something wild and elemental. The technique, however, is the technique of the divided brush stroke, and there is no doubt that this is a picture painted directly from the *motif*. Over all there is the play of light on the surface of objects. Only the silhouette of the peasant woman suggests the flattened outlines of a future style.

Painted in 1887

MARTINIQUE LANDSCAPE

44⅜ x 33½" (113 x 85 cm.)

National Gallery of Scotland, Edinburgh (Gift of Sir Alexander Maitland)

THE MONTHS HE SPENT IN MARTINIQUE during the summer and fall of 1887 (following a few weeks in Panama) reinforced the decorative bent that appeared sporadically in the pictures Gauguin had painted up to this time. He had been closely allied with the Impressionists for several years; now, geographically and stylistically he broke away from them. The strong light and brilliant color of the island, the over-all effect of a luxuriant vegetation that attracted the eye equally everywhere, brought out Gauguin's feeling for the decorative.

It is evident in the tapestry-like handling of this landscape. The masses of the trees, with their shades of green interlarded with warm yellows, are hardly modeled at all. They are simplified into flat, overlapping planes whose edges, sometimes jagged, sometimes rounded, create a rhythm that rises from the foreground road to the hills and sky in the distance. The divided brush stroke of the Impressionist has been broadened and flattened, nor is there an effect of sunlight. There is a richness and depth of color, that instead of reflecting from the highlights seems rather to sink in and penetrate a uniform and textured surface.

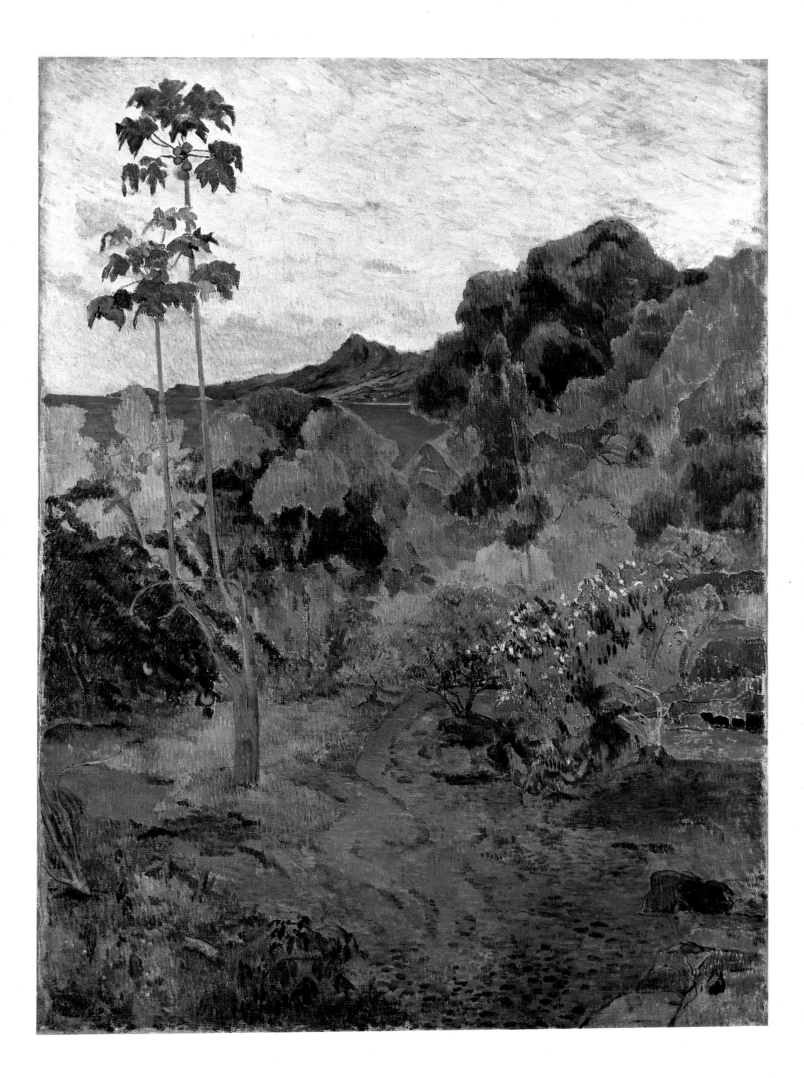

Painted in 1888

BRETON PEASANT WOMEN

28¾ x 35¾" (72 x 91 cm.)

Bavarian State Painting Collections, Munich

A FEW MONTHS BEFORE THIS CANVAS WAS PAINTED, Gauguin wrote to his wife: "You must remember that there are two natures within me: the Indian, and the sensitive. The sensitive has disappeared, which allows the Indian to go straight forward, without wavering." But Gauguin, whether in painting or in personal relations, could not so easily "close his tender heart." As this picture bears witness, he was attracted by what seemed to him the simple poetry of peasant life, the unaffected natures and unquestioning relationships (to each other and to their fields and farms) of the people around him in Brittany. The picturesque character did not escape him, but he subordinated it to a basic feeling of simplicity.

Here he has painted a farm scene as a flat decorative pattern. The Impressionist preoccupation with light which softens form, and with color in its infinite and subtle variations (rendered by broken color and separate brush strokes) suffuses the whole canvas. But the space is flat and there is no horizon. The figures fill the eye from top to bottom of the canvas, the outlines of their arms, white coifs, and incisive profiles make a bold flow of pattern against the rest. Heads have been turned to avoid foreshortening, bodies arranged to emphasize the contours of the spaces between them. The gestures of the arms, the bent heads of the two women on the right recall similar poses employed by Courbet. Perhaps Gauguin was inspired to them by the painter of Ornans. They are in any case similarly intended to suggest the poetry of feeling, akin to a state of grace, found among simple souls and village folk.

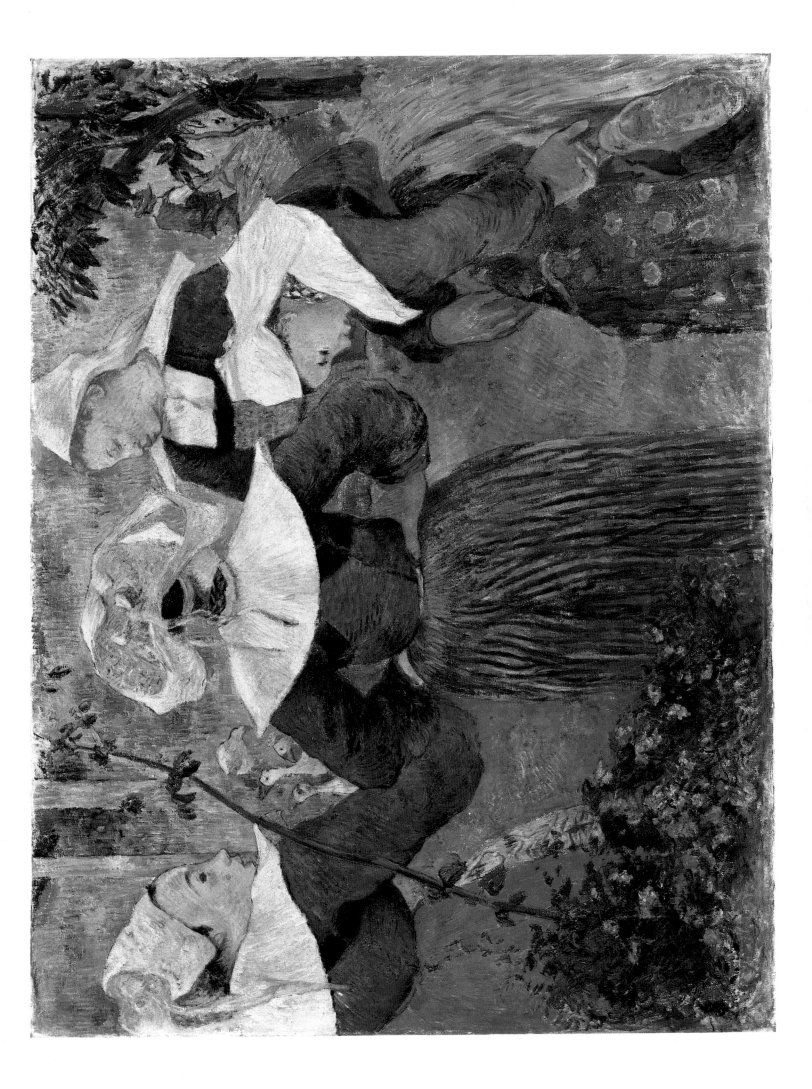

Painted in 1888

JACOB WRESTLING WITH THE ANGEL

28¾ x 36¼" (73 x 92 cm.)

National Gallery of Scotland, Edinburgh

IN THE SUMMER OF 1888, young Emile Bernard, his head full of theories that would overturn Impressionism, arrived in Pont-Aven where Gauguin had been working. Out of their meeting was born "synthetism," of which this canvas, painted at that time, was the first complete result.

It is a bold picture, a religious painting conceived and executed with the faith of a convert to a new artistic credo, but the two faiths were not unrelated in Gauguin's mind: "A word of advice," he wrote to Schuffenecker, "don't copy nature too much. Art is an abstraction; derive this abstraction from nature while dreaming before it, and think more of the creation which will result [than of the model]. This is the only way of mounting toward God—doing as our Divine Master does, create." Thus Gauguin has imagined a peasant vision induced in minds of great and simple faith by a Sunday sermon. In the foreground the peasant women, their backs turned to us, excluding us, as it were, from what they alone can see; in the background the symbolic struggle, two tiny figures on an expanse of unreal red that might be a field or might be the sky. Everything is painted in flat colors separated by clearly drawn contours in a way that is at the opposite pole from Impressionism. There is no color modeling, no blurred edges, no softening of form or hue by an intervening, unifying atmosphere. The unmodulated areas of white, black, blue, and red startle the eye by their contrast; the middle ground has been deliberately omitted to separate the peasants and their vision. For the first time Gauguin gives his composition a pulsating unity by employing throughout the curving, rhythmic contour that is to recur in so many future paintings.

The picture's sources are many: the bent diagonal of the tree trunk and the downward perspective, as well as the outlines suggest the Japanese woodcut generally, while the wrestlers are from a particular print by Hokusaï; the outlines and the flat, bold colors are akin to medieval stained glass and the woodblock of the *images d'Epinal,* both devoted to religious subjects; Impressionism is still evident in the way the frame cuts off the figures. All these sources have been put at the service of a new conception.

"I believe," wrote Gauguin to Van Gogh, "I have attained in these figures a great rustic and superstitious simplicity. It is all very severe."

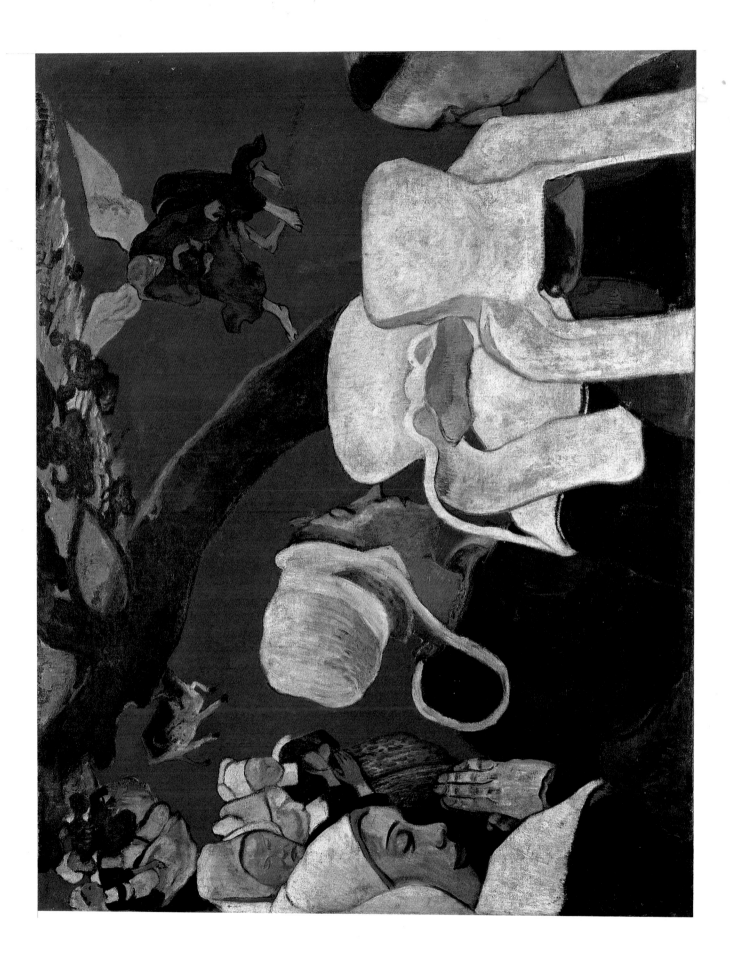

Painted in 1888

THE SWINEHERD, BRITTANY

29 x 36½" (74 x 93 cm.)

Private collection, Los Angeles

THIS PICTURE MAKES IT ABUNDANTLY CLEAR why at this period Gauguin still considered himself an Impressionist. It is painted in divided brush strokes, and barely makes use of outline for certain striking forms such as the pigs in the foreground and the houses behind. Space is depicted, but the receding and overlapping planes fuse into one another without that clearcut sense of interval so characteristic of Cézanne. Indeed the whole left-hand side of the picture might at first glance be by an Impressionist, especially the foreground field. Only the colors—the juxtaposed purples and pinks and mauves—so typical of Gauguin, seem to suggest the style of the future. And yet a second look reveals the continuous curved areas of the later Gauguin; their outlines are still ragged and, so to speak, unkempt, but they are there in the passage above the cow on the left, for example, or the fields to the right of the swineherd, indicating that Gauguin's sense of organization will demand a tighter principle of composition than the suffused light-and-color of Monet and Renoir.

Then too this is a genre picture, painted with sympathy (and perhaps envy?) for the monotonous simplicity of a peasant life apparently without problems. "I love Brittany," wrote Gauguin to his friend Schuffenecker. "I find wildness and primitiveness there. When my wooden shoes ring on this granite, I hear the muffled, dull, powerful tone I seek in my painting."

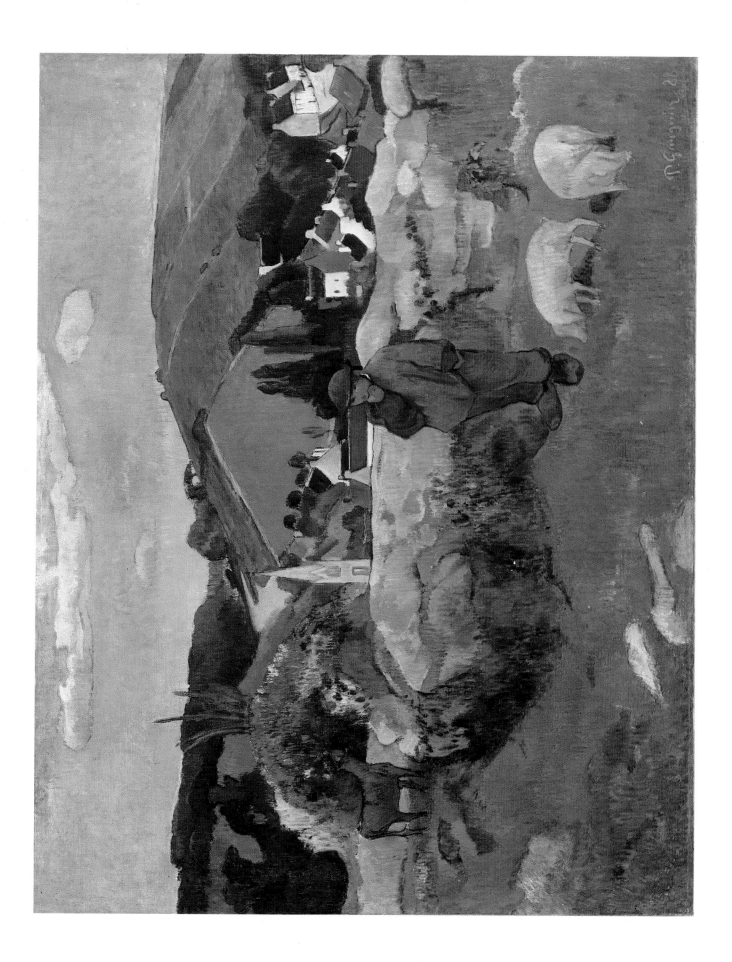

Painted in 1888

STILL LIFE WITH THREE PUPPIES

34¾ x 24⅝" (88 x 62.5 cm.)

The Museum of Modern Art, New York (Mrs. Simon Guggenheim Fund)

"THIS YEAR," WROTE GAUGUIN about the time this picture was painted, "I have sacrificed everything—execution and color—for style, wishing to impose upon myself something else than what I [already] know how to do." This painting is in truth filled with the most brilliant color, but it is color determined by a conception so original, and in many ways so much ahead of its time that one understands how Gauguin could feel that he was forcing himself toward a style he had not previously imagined, subordinating all else in the effort. Perspective has been eliminated, because horizontal and vertical merge, or rather are ignored in the power of the design, and because the size of objects bears no relation to reality. Color also is arbitrary, applied either in large uniform areas (as in the glasses), or in broad, coarse strokes (as in the fruit). Shading and shadow, flattened and broadened, are seen within the context of pattern and design, rather than of mass and modeling. Above all, outline has been thickened and emphasized as an external framework which holds each object together, holds them all so tightly as to make the intervals between immense, as though this were a field, and not a table.

Gauguin's sentences from Arles toward the end of the year are applicable to this picture: "I have no use [for shadows] . . . Look at the Japanese who draw so admirably, and you will see that there is life in the open air and in the sun without shadows. . . . I will have as little as possible to do with what gives the illusion of a thing, and since shadows are the *trompe l'oeil* of the sun, I am inclined to suppress them. . . . Put in shadows if you find them useful, or leave them out, it is all the same."

At this period Gauguin was talking much of "abstraction," a term which seems well ahead of his time, and he was stressing the freedom from nature, the "arbitrary choice" always allowed the artist. In the basic concept of this canvas, besides its humor, its brilliant spacing and spotting of small objects in a large area that seems to anticipate Matisse, it is not exaggerated to mention the "respect of the picture plane"—that phrase dear to Cubist and post-Cubist theorists. Here Gauguin has anticipated this concept too.

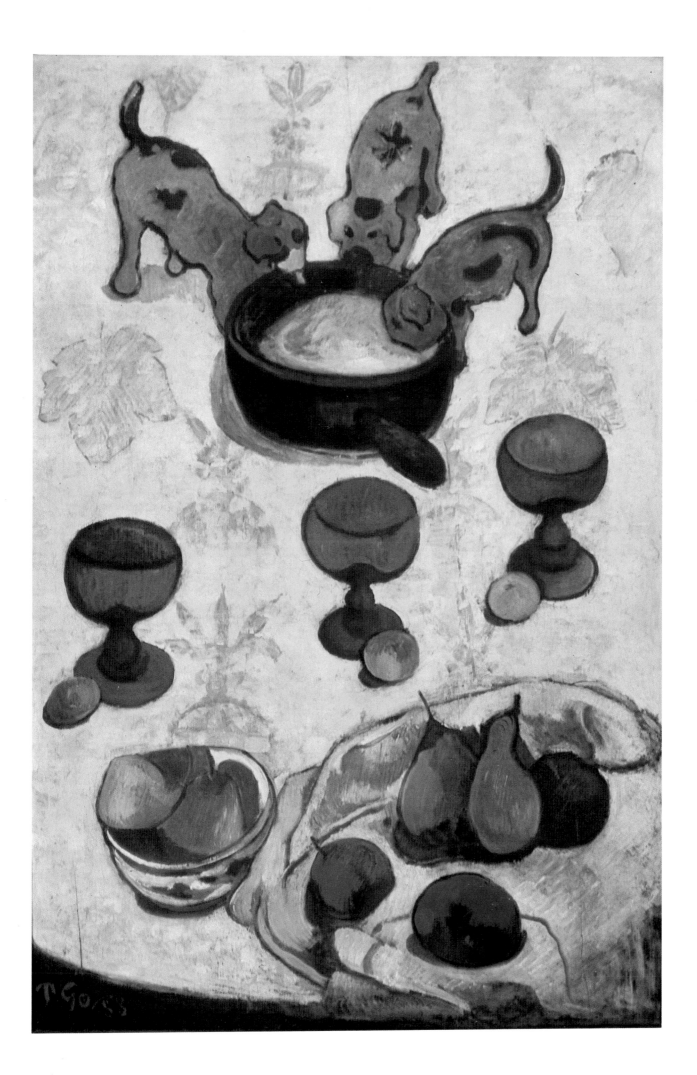

Painted in 1888

LANDSCAPE NEAR ARLES

36 x 28½" (91.5 x 72.5 cm.)

Indianapolis Museum of Art

GAUGUIN'S TWO-MONTH STAY IN ARLES which ended on Christmas Day, 1888, was emotionally surcharged. Despite this, and the intensity of his relation to Van Gogh, his sojourn in the South affected but little the main course of his painting. While he briefly influenced Vincent's style (compare the *Arlésienne*, page 31), Vincent's fervent nature produced its impact upon Gauguin the man rather than upon the manner of his art.

When Gauguin did see the Midi through any other eyes than his own, it was more through those of Cézanne than of Van Gogh. Here the cubic structure of horizontals and verticals, the overlapping planes of walls and houses, the colors of the plaster surfaces reflecting their surrounding light, the orange tiled roofs and the blue trees and distant hills all reveal the vision of Cézanne. Only the bold strokes of the foreground with their sense of the movement of the hand in their application, the obvious broken-color technique of the grass and haystack, as well as the higher-keyed more acid hues, suggest that Gauguin was painting side by side with Van Gogh. In all these respects this picture is exceptional—and important. It makes us realize that Gauguin, for all his fierce independence of character and style, was an artist who, without copying, understood and absorbed what he needed from the work of the great men around him.

64

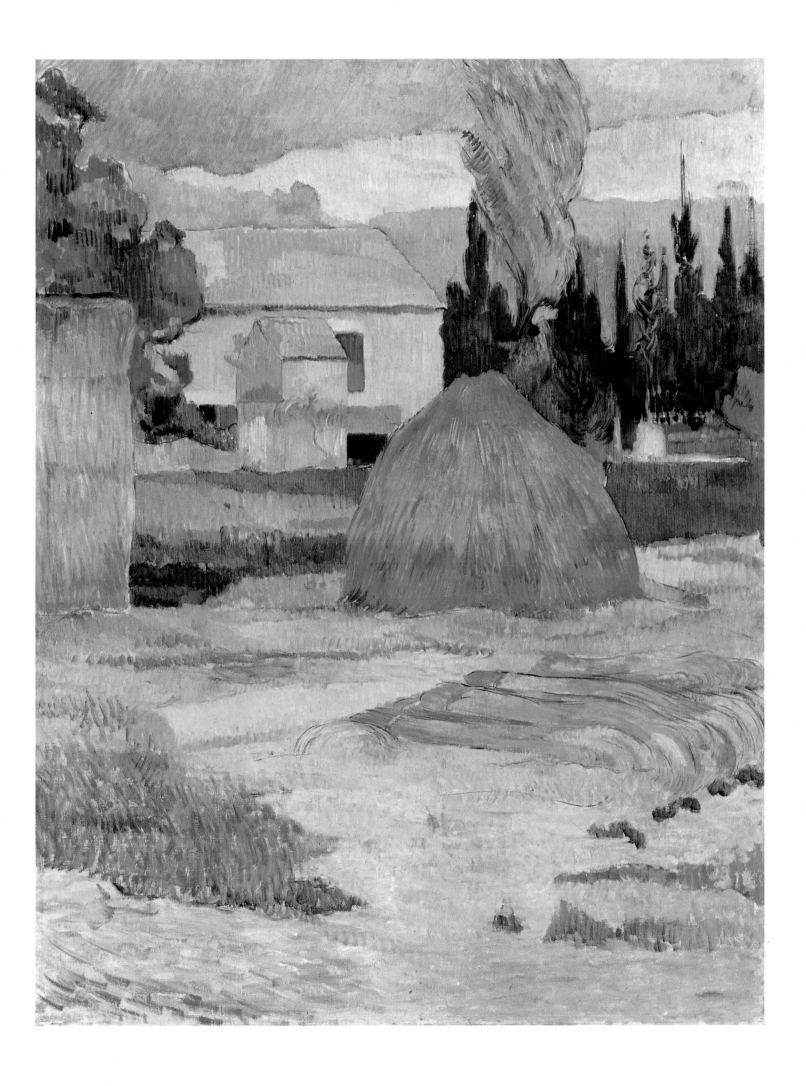

Painted in 1889

STILL LIFE WITH HAM

19¾ x 22¾″ (50 x 58 cm.)

The Phillips Collection, Washington, D.C.

THIS SMALL AND SIMPLE PAINTING is one of the most direct of Gauguin's canvases. It is obviously carefully arranged: the placing of the table, with one edge free, the other slightly hidden beyond the frame of the picture, and of the bands of the wallpaper, attest to a thoroughly worked-out composition. Yet the table, with its platter, scattered onions, and glass of wine, have apparently been come upon casually and seized and set down at a glance.

Most striking is the combination of volume and pattern, the table top, and the objects on it viewed from above, and so seen in depth. But the wall behind is altogether vertical. It brings the eye up short and the strong vertical stripes, close to the eye, contradict the space suggested by the still life in the foreground. But if actual space is denied, immense abstract space is at once implied; for the red beads of the wallpaper, continuing into space above and below, seem to detach themselves from the yellow surface to which (in reality) they belong, and the solid wall is transformed by its own color and by its contrast, into a luminous, intangible space. Thus, without Cubism's devices, Gauguin has made a picture, which like those of that later style, penetrates solidity, and hovers between the real and the unreal.

66

Painted in 1889

THE YELLOW CHRIST

36⅜ x 28¾" (92.5 x 73 cm.)
Albright-Knox Art Gallery, Buffalo

CONSTRUCTED OF FLAT PLANES, intense colors, and bold outlines, the *Yellow Christ* is the apogee of Gauguin's "synthetist" style. The plane of the canvas—the surface which must be respected—is held by the foreground figure, the strong upright of the crucifix, and the terminating horizontal bar. Against the repeated bands of field and sky and cross, the swinging curves of the women and the trees (closed forms that contrast with the movement of the straight lines) play a graceful counterpoint, the whole drawn together by a bright and simple pattern. The colors are gay, but the starkness of the Breton landscape is conveyed; the women are gentle but their peasant force is still evident.

Even today this is a striking canvas. How much more so it must have appeared at the time it was painted, when the subtle delicacies of the Impressionists' divided brush stroke were still considered revolutionary! The uniform color surfaces, the lines that ring the figures are deliberately crude and simplified, at the opposite pole from Impressionism. Yet Gauguin has observed with care: the costumes are accurate, the light is the cold light of Brittany, the field contains harmonies of green, rust, and yellow. And we know besides that the figure on the cross is closely derived from a Crucifixion in the church of Tremalo not far from Pont-Aven. But the artist has gone beyond naturalistic observation to emotional expression. "The Impressionists," he wrote later in his *Intimate Journals*, "study color exclusively, but without freedom, always shackled by the need of probability. For them the ideal landscape, created from many entities does not exist. . . . They heed only the eye, and neglect the mysterious centers of thought, so falling into merely scientific reasoning." It is this ideal expression that is Gauguin's goal. Sophisticated painter, traveler, and man from the capital though he may be, and no peasant (indeed because he is all these) he wants his canvas to convey, because it contains, the "great rustic and superstitious simplicity" he found among the Breton people. And so he has simplified the construction of his picture, flattened its space, coarsened its outlines, and heightened its colors, to make it no longer merely an objective record set down by an external observer, but the direct, visual symbol of a naive and trusting religious faith. "A child's tears," Gauguin wrote from Brittany at this time, "are also something and yet they haven't much worldly wisdom."

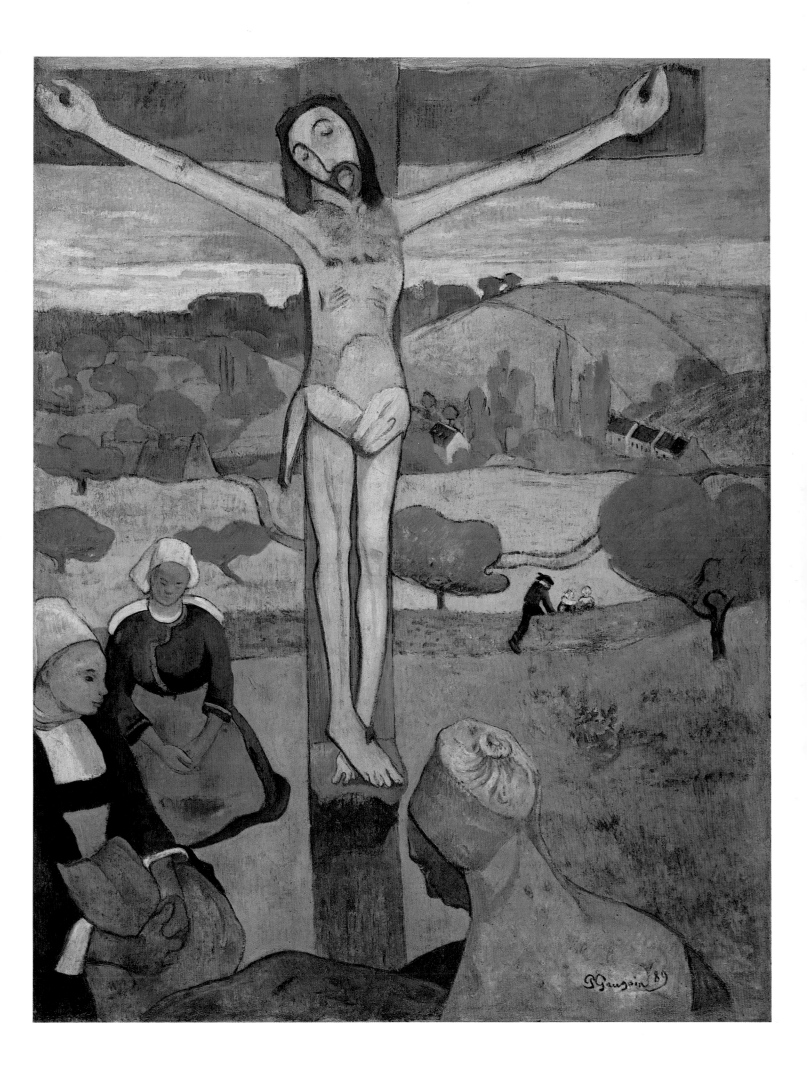

Painted in 1890

PORTRAIT OF A WOMAN (Marie Henry?)

25½ x 21½" (64.8 x 54.6 cm.)

The Art Institute of Chicago (Joseph Winterbotham Collection)

LIKE HIS FRIENDS of the *avant-garde*, both older and younger, Gauguin admired Cézanne. At different times Pissarro had been mentor to them both, and through him they had met in the summer of 1881. It is not surprising that the two men, both proud, suspicious natures, did not get along personally. But even earlier, Gauguin had bought several of Cézanne's canvases, and when hard times forced him to sell his collection, he refused to part with the still life shown in the background of the painting. "I cling to it as dearly as to my life," he wrote to Schuffenecker, who had offered to buy it in order to help him out, "and short of absolute necessity would rather part with my last shirt." Their art moved in different directions, but both began as Impressionists, and Gauguin was well placed to respect the insistence of the Aixois upon being himself.

In this canvas the kinship with Cézanne is strongly felt. It is evident in the diagonal placing of the sitter, with the extended arms (one longer than the other) enclosing the space between them; in the expressionless face; and in the relation of the figure to the still life behind it. There is (for Gauguin) an unaccustomed bulk and weight to the body, given by a modeling in colored patches that is seen most clearly in the hand and the head. The rhythm is the angular rhythm of Cézanne, the contours broken into by darker areas in his characteristic fashion, unlike the undulating, smoothly outlined forms Gauguin more usually employs. Even the richer, warmer color harmonies are exceptional. All this bespeaks the influence of the southern master's vision. Cézanne did not like Gauguin's art; he decried his lack of modeling and gradation, said he was not a painter, but a fabricator of "Chinese images," i.e., of flat and weightless silhouettes. But if here Gauguin has, for once made direct use of that *petite sensation* of which Cézanne was so jealous, the master of Aix might well forgive him, for in his own fashion he has truly penetrated and transcribed the solidity and seriousness which were the older artist's aim.

70

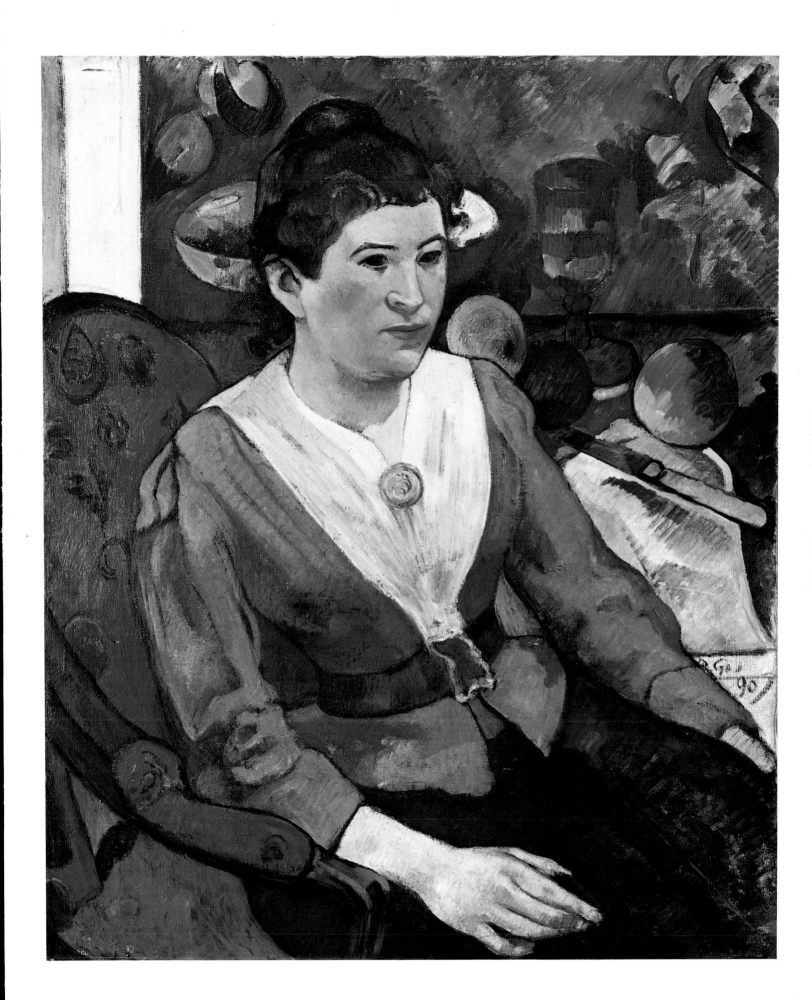

Painted in 1890

THE HAYRICKS

29¼ x 36¾" (74.5 x 92.5 cm.)

*National Gallery of Art, Washington, D.C. (Gift of the W. Averell
Harriman Foundation in memory of Marie N. Harriman)*

THIS PICTURE WAS PAINTED only a few months before Monet began his
famous series of *Haystacks*. Comparison between them shows the differ-
ences between late Impressionism and the new style Gauguin has now made
his own. The "synthetism" of the two previous years, once a pervading pro-
grammatic principle of composition, has been absorbed and subdued, used
naked, so to speak, only where it is called for, as in the lower right-hand
corner, elsewhere modified and softened, as in passages of the upper left.

There is here a beautiful balance of elements: decorative pattern and
deep space; curved forms and straight lines; outline in some areas, blended
edges in others. The red curves of the foreground, with their strong con-
tinuous contours and separation of areas, contrast with the spotted hues and
lively stippled effect of the flowering garden beyond, and these in turn give
way to the linear alternation of the furrowed field. Only after some time
does one realize the unity within the diversity of the whole foreground—
the similar abstract quality of the three different treatments, in contrast to
the more conventional handling of the background. The figure of the peas-
ant woman has a double function: it gives scale to the whole view, par-
ticularly the breadth and depth of the distant fields, and it is symbolic of
the intense relation of the peasant to his land, the peasant who has created
the rhythmic structure the painter reveals.

Painted in 1891

WE GREET THEE, MARY (Ia Orana Maria)

44¾ x 34½" (114 x 89 cm.)

The Metropolitan Museum of Art, New York (Bequest of Samuel A. Lewisohn)

IN THE SOUTH SEAS AS WELL AS IN BRITTANY, Gauguin painted religious pictures, yet he was far from being a religious man in the ordinary sense. He was rather something of a mystic, and something of a Rousseauian believer in the original goodness of man when uncorrupted by society, part of a long line of writers and artists who placed more store in the universal human values common to all religions than in the dogmatic traditions of any one. In this spirit he went back to the primitive generally, and in the same spirit, soon after he arrived in Tahiti, painted this Adoration of the Shepherds, as he supposed it must appear to the Tahitians, just as he had previously portrayed the religious visions of the Breton peasants.

Gauguin described the picture in a letter of March, 1892: "An angel with yellow wings points out to two Tahitian women Mary and Jesus, also Tahitians. Nudes dressed in *pareos*, a kind of flowered cotton cloth which is worn as one likes around the waist. The background [is] of very somber mountains and trees in flower. A dark purple road and green foreground; to the left some bananas. I am rather pleased with it."

This is the subject baldly enumerated by listing its parts. But it hardly describes the picture or explains its appeal. For it does not include its essential elements as a painting: the bright coloring of the main actors, that sets them off, yet leaves them part of their surroundings; the balance of the repeated verticals of trees and figures against the receding horizontal bands of the ground; the sense of peace and ease which makes this at the same time one of the least mysterious and most monumental of Gauguin's canvases. Like some of Raphael's paintings, it is a picture so harmonious as to appear obvious. It takes some time before we see how closely knit the structure is, and perceive the wealth of detail included at no detriment to the main scene, as if the luxuriance were itself a tribute.

And there is even more in combination here than Tahitian setting, native faith, and Western iconography. The motif of the adoring women side by side, their flattened figures both foreshortened and frontal, comes from the East. Gauguin took it directly from a sculptured frieze of the Javanese Temple of Borobudur, photographs of which he had bought in Paris in 1889, at the time of the World's Fair. Thus all parts of the globe are united in a single theme, common to them all.

74

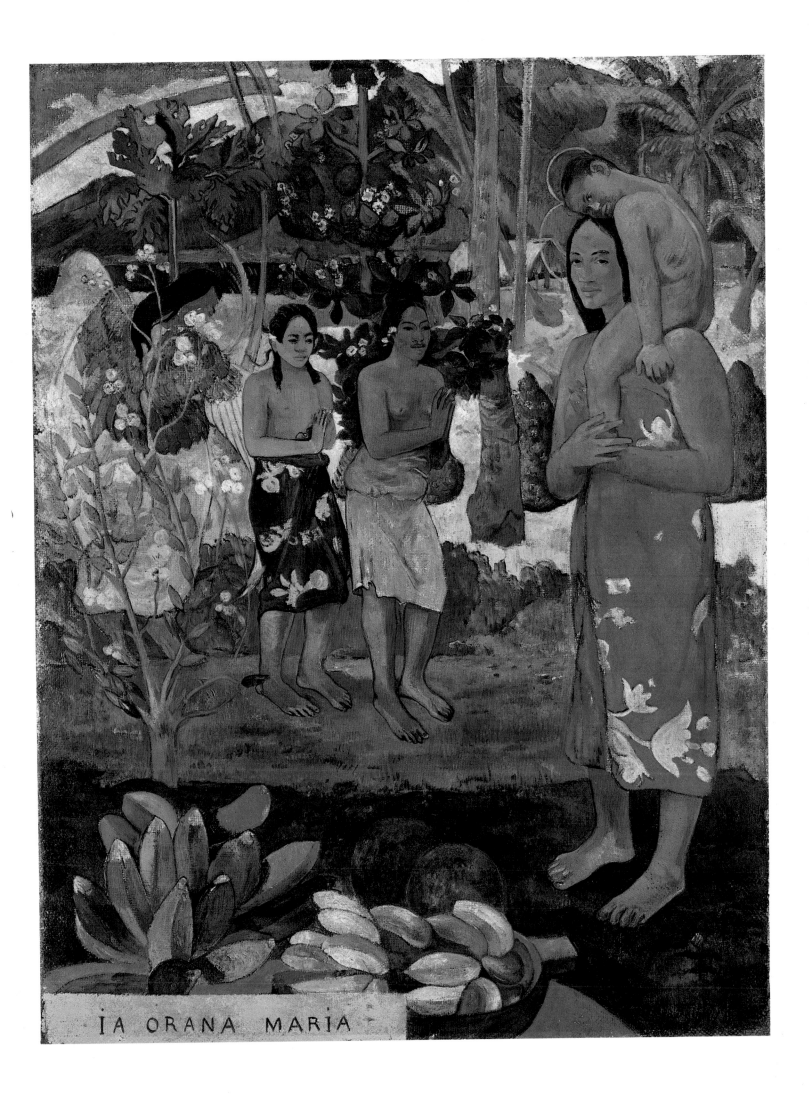

Painted in 1891

REVERIE

37 x 26¾″ (95 x 68 cm.)

Nelson Gallery–Atkins Museum, Kansas City, Missouri (Nelson Fund)

OVER GAUGUIN'S SOUTH SEA WORLD, there somehow hangs a veil of melancholy. In his letters and journals he may talk of the delights of savage existence—of "civilization from which you suffer, barbarism, which for me is a rejuvenation"—but he does not paint it. He may talk of the unselfconscious Eve of Oceania, but he does not paint her.

Was the melancholy mood he so often communicates truly observed; was it really to be found among his Tahitian neighbors, whose naturalness and simplicity he preferred to the artificialities of the European colonials, or was it the sadness of his own feelings that he rendered? In any event the mood is there: in the poses which are as often constrained as they are languorous, in the expressions, which are more often sad than limpid, in the colors, whose lack of clear light and contrast lends a mournful, evening glow to their luxuriance. This woman, in her heavy garment, her thoughts turned inward and robbing her of all energy, is surely no spontaneous savage. Baudelaire, who like Gauguin had a longing for the primitive, and who in esthetic theory is one of the painter's immediate ancestors, would have recognized and greeted her: she seems at the mercy of that most civilized of all maladies, the poet's own—*ennui*.

76

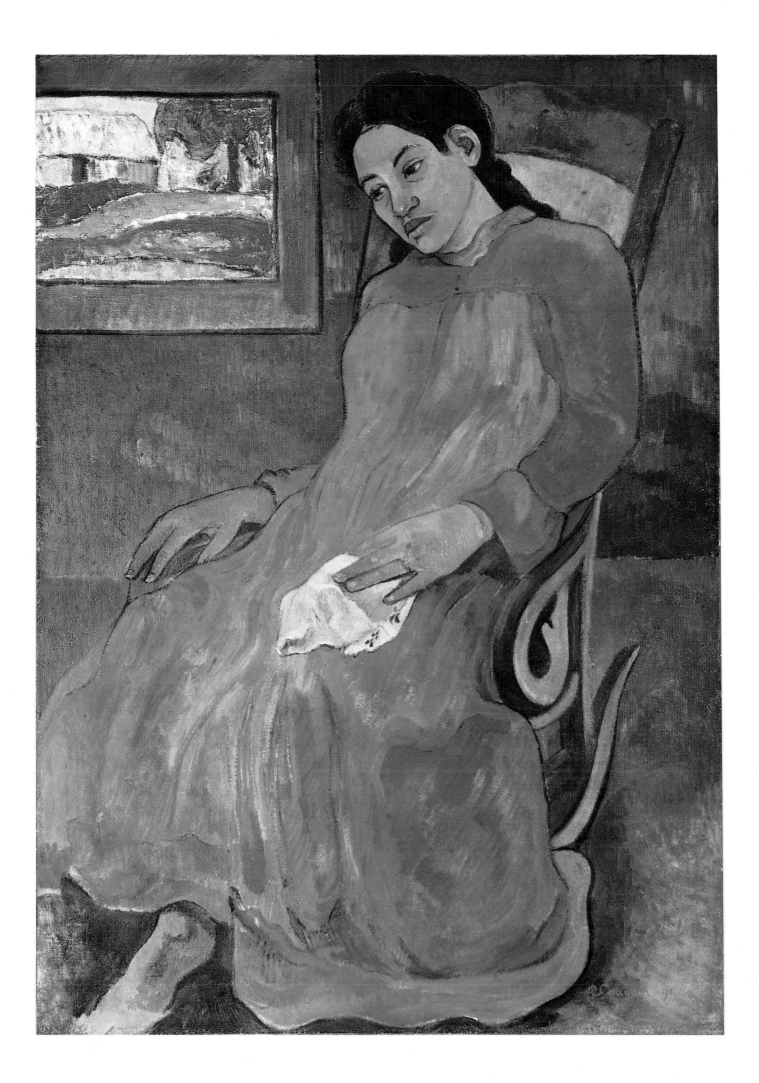

Painted in 1891

STILL LIFE WITH FLOWERS

37¼ x 24½" (95 x 62 cm.)

Collection Stavros Niarchos

LIKE THOSE OF MANY ARTISTS, Gauguin's theoretical ideas were consistent in their fundamentals (because he was true to himself as an artist), but contradictory in their details (because he was thinking about different kinds of painting at different times). He wrote: "The Impressionists study color exclusively, but without freedom, always shackled by the need of probability." But he also wrote: "What is sweeter to an artist than to make perceptible in a bunch of roses the tint of each one? Although two flowers resemble each other, can they ever be leaf by leaf the same? . . . Why embellish things gratuitously and of set purpose? By this means the true flavor of each person, flower, man, or tree disappears. . . . This does not mean that you must banish the graceful subject, but that it is preferable to render it just as you see it rather than to pour your color and your design into the mold of a theory prepared in advance in your brain."

This contradiction he shared with Odilon Redon who, like Gauguin was an artist who wished to suggest rather than describe (he said of the Impressionists that their ceiling was too low), but who painted brilliant floral still lifes with loving care and the utmost attention to minute detail. Indeed Gauguin said that he carried with him to Tahiti the memory of all Redon's works, and the affinity can be felt in this painting. For though its execution has Gauguin's characteristic broadness, and though the lower portion is carried out in his more usual somber colors, the flowers themselves have the brightness and the contrast (and especially the opposition of red and blue) that recalls Redon's more delicate renderings. The vase is one of Gauguin's own manufacture, decorated with a motif found in several of his woodcuts and paintings, and the mask behind introduces a characteristic note of exotic mystery. These are subordinated to a display of bright, and even acid color rare among his Tahitian works.

78

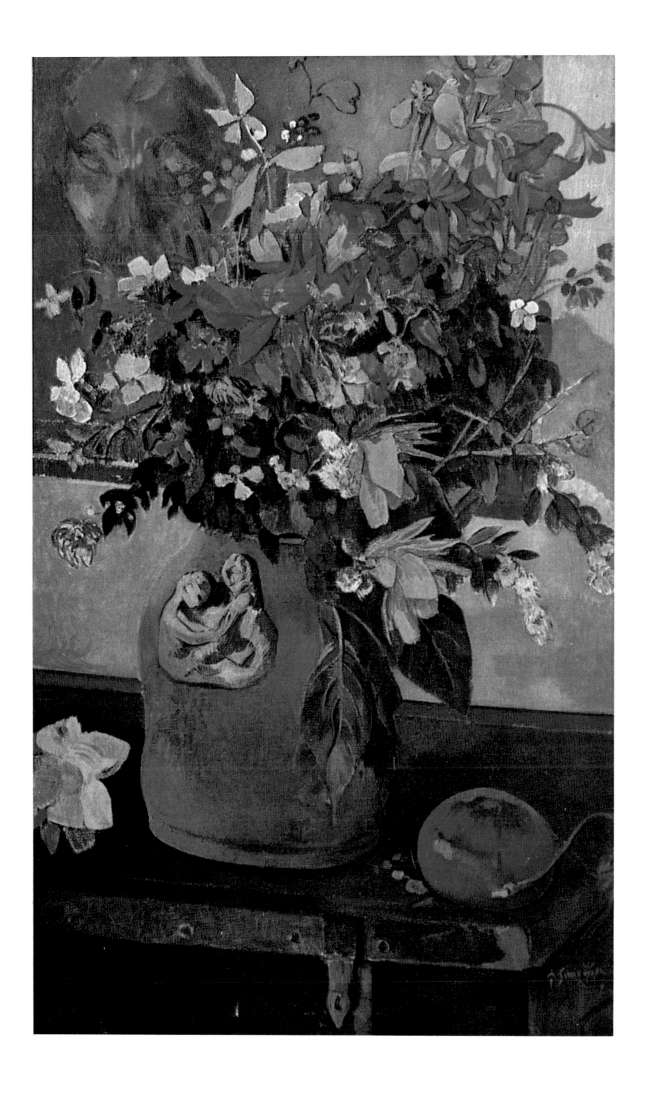

Painted in 1891

TAHITIAN LANDSCAPE

26¾ x 36⅜" (68 x 92.5 cm.)
Minneapolis Institute of Arts

"YOU ASK ABOUT WHAT I DO," wrote Gauguin in November of this year, just five months after his arrival in Tahiti. "It is hard to say, for I myself don't know what it is worth. Sometimes I find it good, and at the same time find it looks awful . . . I am satisfied to search within myself, and not [to examine] nature, and to learn to draw a little . . ."

Nevertheless Gauguin did look about him, was affected by his new surroundings, especially by a new-found silence, by a sense of eternity, very different—or so it seemed to him—from the activity, the struggle, the tension of European life. "I feel all this penetrating me and can now rest in extraordinary fashion."

Something of this new-found peace pervades this picture. It is composed on large lines, with few elements. Its scale, suggested by the single, small figure in the foreground, is enormous, and there is an exceptional sense of light and depth, a harmony of nature untroubled by overtones of mystery. Curiously, the top of the mountain's peak suggests the profile of Cézanne's Mont St. Victoire. This is surely coincidence. The color harmonies, the repetition of curves, the broad surfaces are Gauguin's own. For once Gauguin is at peace with nature's spectacle, willing in simple fashion (like an Impressionist!) to equate its surface with its secret.

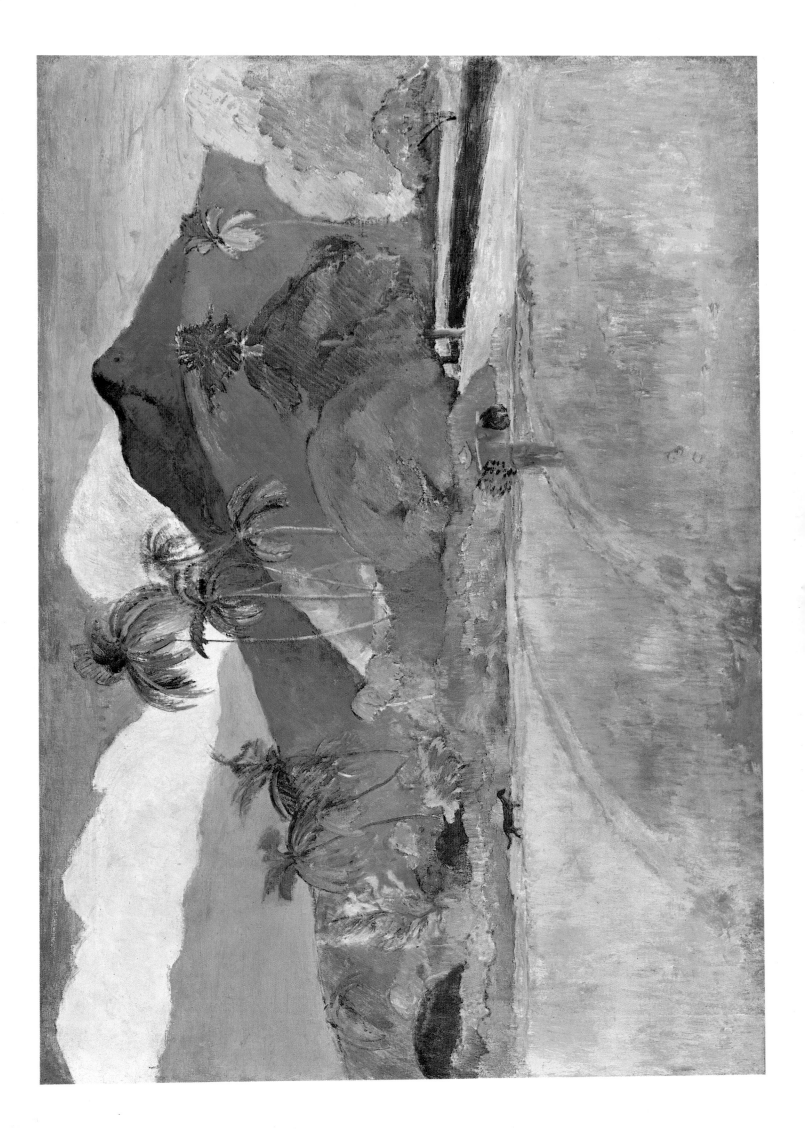

Painted in 1891

TAHITIAN WOMEN

27⅛ x 35⅜" (69 x 90 cm.)
Museum of Impressionism, The Louvre, Paris

HOW TO COMBINE SOLID FORM and flat pattern—this seems the problem the Post-Impressionists so often posed for themselves. Seurat solved it through pointillism, Cézanne by employing color modeling. In this painting Gauguin, who so frequently uses the composition of the flowing frieze to this same end, has joined solidity and surface by other means.

The view from above both foreshortens the figures and eliminates the horizon, thereby bringing the background forward. The figures themselves, close to the eye, create a pattern of curved forms that contrasts with the straight, simple lines of the shore beyond. Being so near, filling so much of the area, they are both on the surface and in depth, both flat and modeled. The fusion of the two is especially clear in the woman on the left whose profile and arm make one continuing vertical contour as her extended leg and skirt make a horizontal one, both also functioning as receding diagonals, while at the same time the foot balances the hand close up in the corner. Thus the large color areas, bound together by strong outlines that, through overlapping, create an abstract pattern, are also used to model and give weight to the heavy bodices.

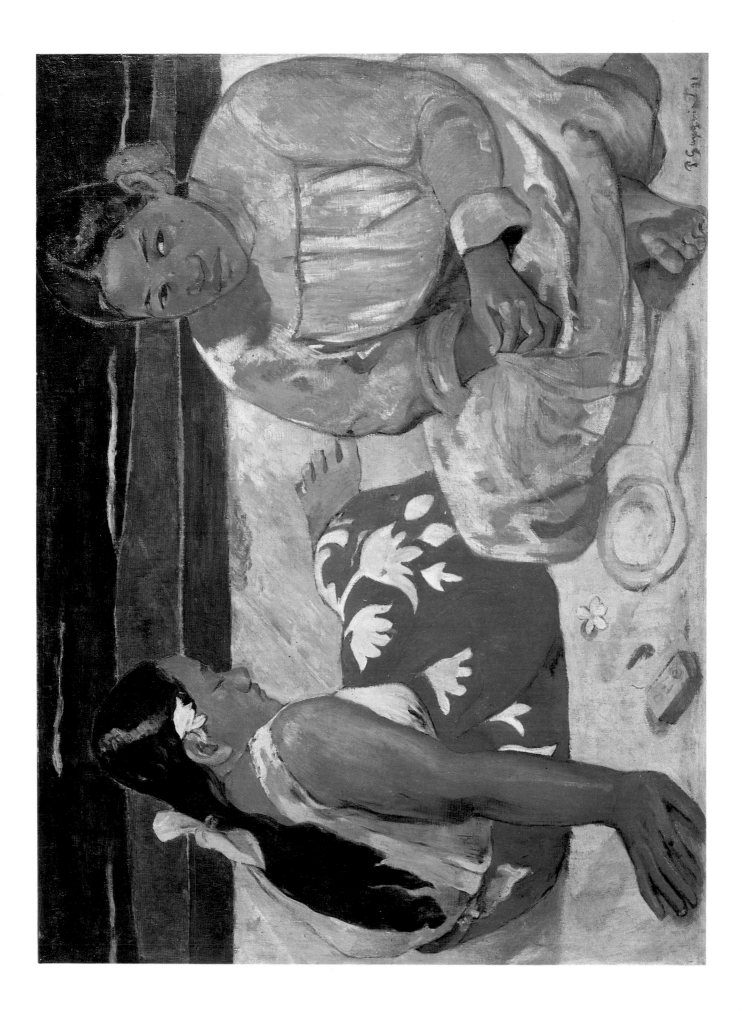

Painted in 1892

TA MATETE

28¾ x 36¼″ (73 x 92 cm.)
Kunstmuseum, Basel

IT IS ONE OF THE MOST CONSTANT CHARACTERISTICS of Gauguin's art that while his sources of inspiration remain clear and undisguised, they contribute to an entirely original creation. Here unmistakably Egypt has been put to his own uses: the sequence of seated figures, all aligned and hardly overlapping, the combination of profile and frontal views, the rigid gestures, the long robes, the accentuated fingers, and the accented silhouettes, recall the intaglio reliefs of the temples of the Nile. "Line is a means of accentuating an idea," said Gauguin. The clarity of the Egyptian technique, its rhythmic alternation of bodily contour and intervening space, its unifying harmony of proportion which allowed him both the "mystery" of which he was so fond, and a grace without softness, all these appealed to the painter's sense of style.

"Have always before you the Persians, the Cambodians, and a little of the Egyptians." Although this, perhaps Gauguin's most famous critical phrase, was actually written in connection with sculpture in the round (and at a somewhat later date), it fits this canvas perfectly. For to the incisive Egyptian contour and pose have been added the flat color areas of the Persian print, and the spaced verticals of the backgrounds of Indonesian reliefs.

Of course Gauguin, in Tahiti, had never seen any such hieratic, solemn, and well-ordered frieze of figures, static in themselves, full of movement to the eye in their rhythmic arrangement. He translated his everyday reality through this wide diversity of styles, because they helped him to create the mood—simple, dignified, and full of wonder—that for him was the meaning of primitive.

84

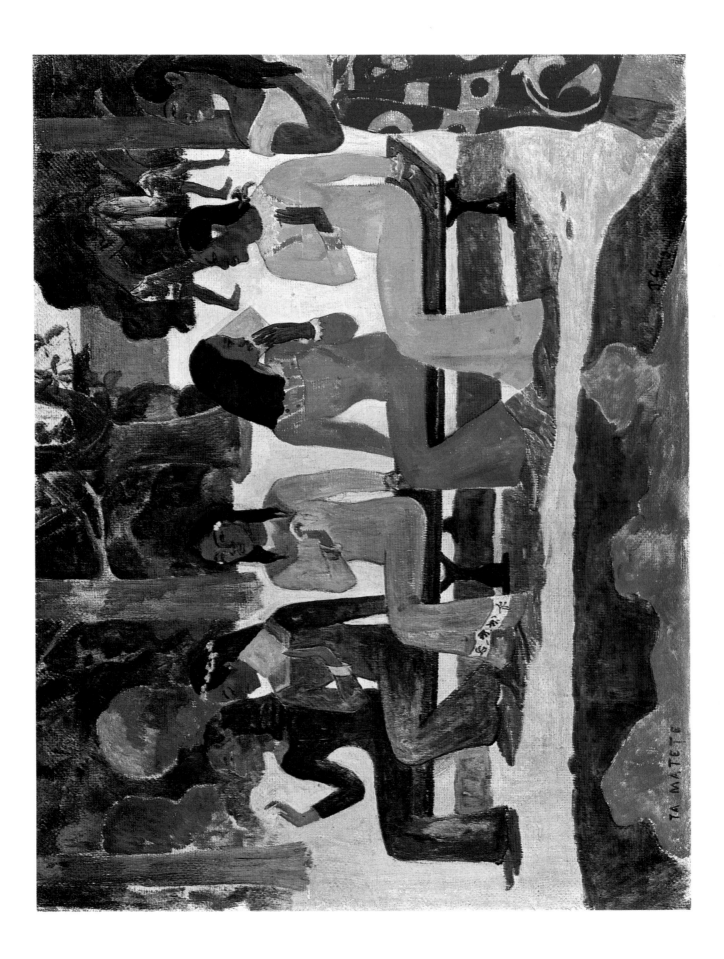

Painted in 1892

WHISPERED WORDS (Parau-Parau)

30 x 38″ (76 x 96.5 cm.)

The John Hay Whitney Collection, New York

IN THIS CANVAS Gauguin seems to have gone back five years to the tapestry-like landscapes of Martinique (page 54) with their rich and textured surface. Colors and contours are softened, light toned down by an atmosphere that appears to penetrate figures and ground and trees, giving the whole an almost Venetian aspect that rounds the forms while preserving the pattern. Here, in abundance, is that *matière* of which Gauguin was so aware, and which we associate too little with his art.

What feeling did he wish to evoke? He tells us himself in one of the many notes he wrote about his painting:

"To explain my Tahitian art, since it is held to be incomprehensible:

"Wanting to suggest a wild and luxuriant nature, and a tropical sun which makes everything around it blaze, I had to give my figures an appropriate setting. It is really life in the open—an intimate life all the same, among the thickets and the shaded brooks; these women whispering in an immense palace which Nature herself has decorated with all the riches that Tahiti holds. Hence these fabulous colors, this fiery, yet soft and muted air.

"But all this does not exist!

"Yes, it exists as the equivalent of this grandeur and profundity, of this mystery of Tahiti, when it has to be expressed on a canvas three feet square.

"The Tahitian Eve is very subtle, very knowing in her naivete. The enigma hidden in the depths of her childish eyes remains incommunicable to me. She is Eve after the Fall, still able to walk naked without shame, possessing all her animal beauty of the first day. Like Eve, her body has remained animal, but her head has evolved, her mind has learned subtlety, love has impressed an ironic smile upon her lips, and naively she searches her memory for the *why* of present times. Enigmatically she looks at you.

"All this is intangible, they say.

"So be it, I am willing to agree."

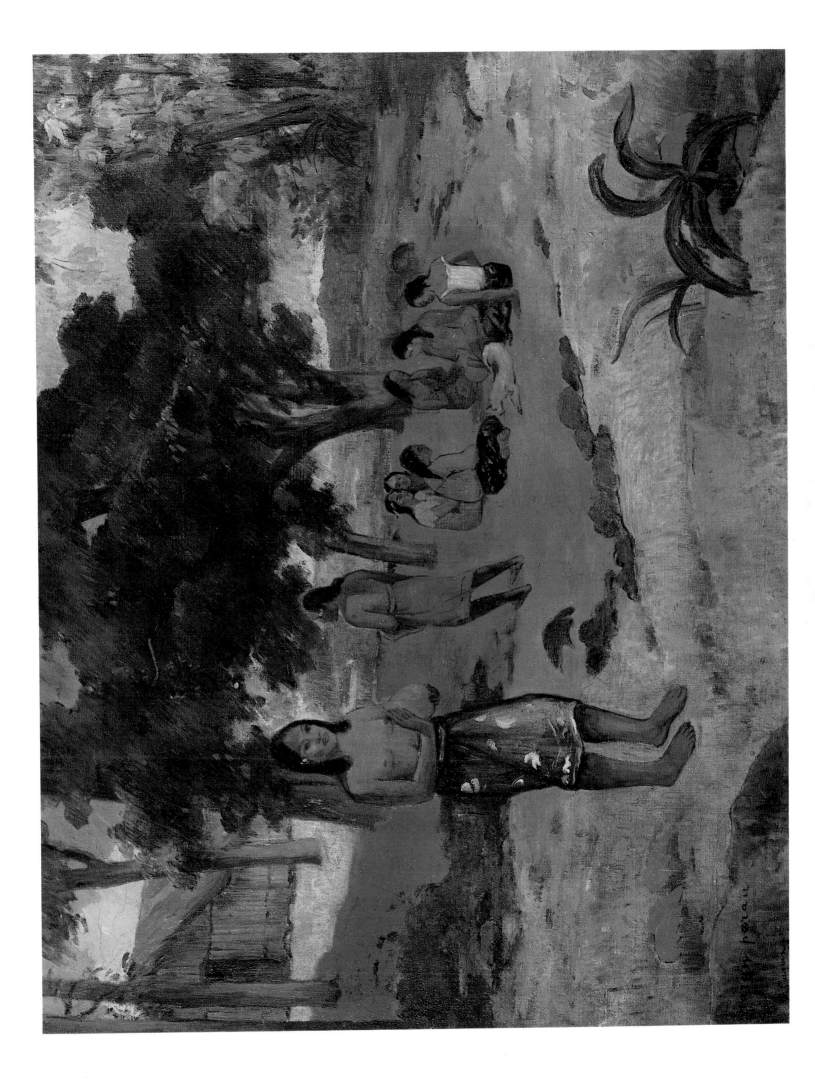

Painted in 1892

SPIRIT OF THE DEAD WATCHING
(Manao Tupapau)

28¾ x 36¼″ (73 x 92 cm.)

Albright-Knox Art Gallery, Buffalo(A. Conger Goodyear Collection)

GAUGUIN'S SYMBOLISM, his desire to be "mysterious," is nowhere more evident than in this canvas. Perhaps the *Olympia* of Manet (which Gauguin once copied) is related to it, but clearly Gauguin, unlike the older master, intended more than simply a beautifully painted nude. Fortunately, he has himself told us something of his aim, for in his letters and journals he wrote extensively of this picture, as though it were a characteristic example of the methods and goals of his art:

"A young native girl lies on her belly, showing a portion of her frightened face. She lies on a bed covered with a blue *pareo* and a light chrome-yellow sheet . . . Captured by a form, a movement, I paint them with no other preoccupation than to execute a nude. As it stands, it is a slightly indecent study of a nude, and yet I wish to make a chaste picture of it, and imbue it with the native feeling, character, and tradition.

"The *pareo* being closely linked with the life of a Tahitian, I use it as a bedspread. The sheet, of bark-cloth, must be yellow, because, in this color, it arouses something unexpected for the spectator, and because it suggests lamplight . . . I need a background of terror, purple is clearly indicated. And now the musical part of the picture is all set out . . .

"I see only fear. What kind of fear? Certainly not the fear of Suzanna surprised by the elders. That does not exist in Oceania. The *tupapau* (Spirit of the Dead) is clearly indicated. For the natives it is a constant dread . . . Once I have found my *tupapau* I attach myself completely to it, and make it the motif of my picture. The nude takes second place.

"What can a spirit be, for a Maori? She knows neither theater or novels, and when she thinks of someone dead, she thinks necessarily of someone she has seen. My spirit can only be an ordinary little woman . . .

"The title has two meanings, either she thinks of the spirit; or, the spirit thinks of her.

"To sum up: the musical part: undulating horizontal lines, blue and orange harmonies tied together by yellows and purples (which are their derivatives), lit by greenish sparks. The literary part: the soul of a living person linked to the spirit of the dead. Night and Day."

If we read "abstract" for "musical" we can understand something of how Gauguin, caught by a feeling he does not quite understand, has allowed it to suggest his picture to him, and has then tried to translate this feeling into purely visual (rather than literary) terms.

"This genesis is written for those who must always know the whys and the wherefores. Otherwise, it is a simple study of an Oceanic nude."

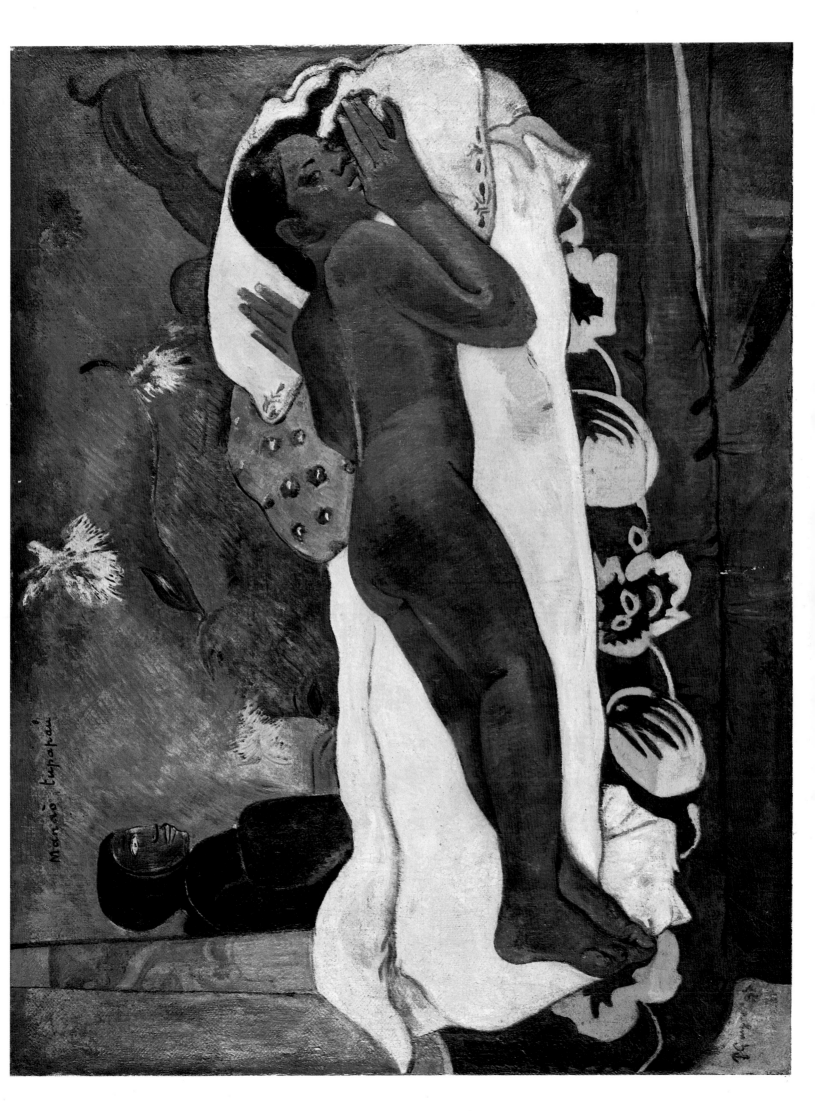

Painted in 1892

FATATA TE MITI

26¾ x 36″ (68 x 91.5 cm.)
National Gallery of Art, Washington, D.C.(Chester Dale Collection)

DURING HIS FIRST TAHITIAN SOJOURN Gauguin's style grew more graceful. Alone, no longer the master surrounded by disciples, less immediately conscious of his revolutionary role, he allowed his sensibility to attenuate his programmatic zeal. Yet the "synthetist" direction of the Breton paintings was by no means forgotten.

In August of the year this canvas was executed, he wrote to Daniel de Monfreid: "I see you have found an artistic potboiler; I congratulate you; it can only do you good to be forced to decorate. But beware of modeling. The simple stained-glass window, attracting the eye by its divisions of forms and colors, is still the best. A kind of music. Strange that I was born to do decorative art and that I have not been able to achieve it. Either windows, or furniture, or faïence, or whatever... There lie my real aptitudes much more than in painting properly speaking."

And although Gauguin did not quite mean this (he was understandably envious of the money-making possibilities), such a canvas suggests that he was correct in his estimate of one side of his talent. Flat colors, abstract shapes, sweeping, unbroken curves, all unite to make an integrated pattern of decoration. It is an arbitrary pattern that flows insensibly from forms rooted in nature, through stylization to pure invention, and it is a pattern that, in its large elements of continuous line and its small ones of irregular color areas, fills the canvas and gives it movement, and yet permits the figures to stand out in boldness and clarity. This movement is the painting's "music," at once symbolic and abstract, interpreting and reinforcing the subject through the eye alone. Thus for all its arbitrariness, the scene is suddenly natural, for all its flatness, suggests space, and for all its movement, is calm and quiet.

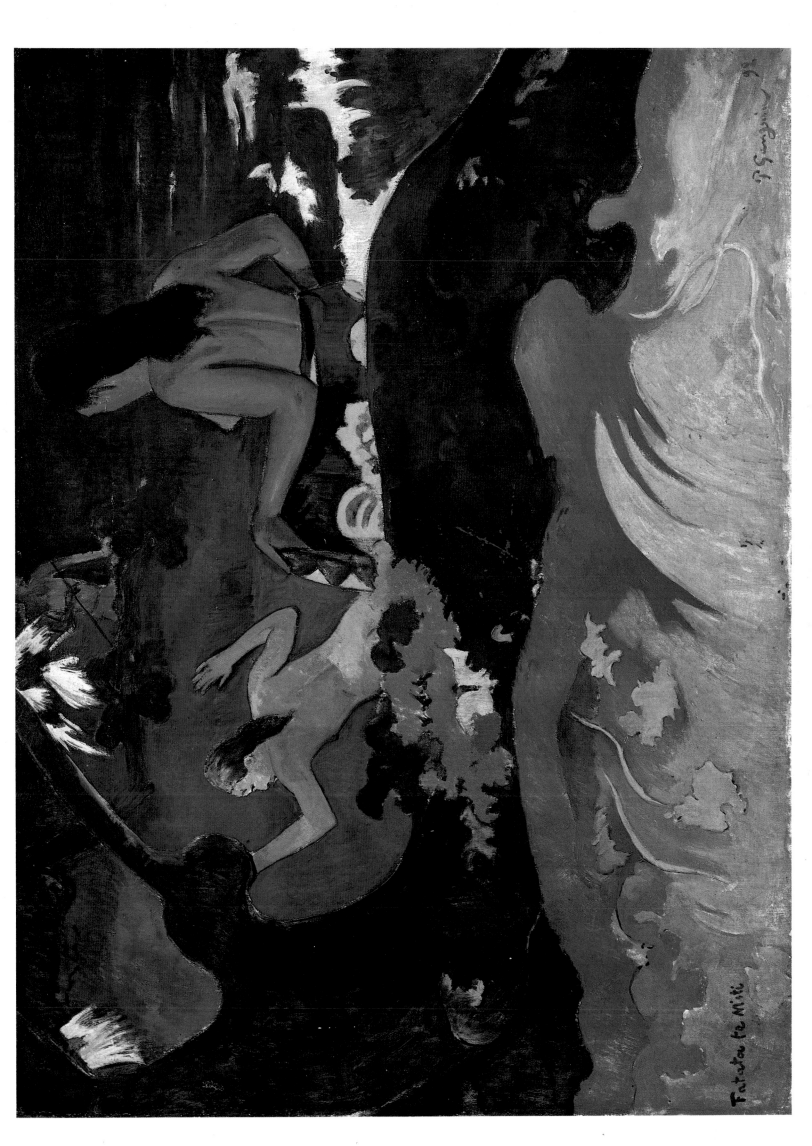

Painted in 1892

SACRED MOUNTAIN (Parahi Te Maras)

26 x 35" (66 x 89 cm.)

Collection Mr. and Mrs. R. Meyer de Schauensee, Devon, Pa.

"MY ARTISTIC CENTER IS IN MY HEAD," wrote Gauguin to his wife, from Tahiti, in the year this picture was painted. And years later he was still insisting: "I am not a painter who works from nature. With me, everything happens in my wild imagination." No picture bears him out more than this strange composition, put together out of Maori legends (or his interpretation of them), his notion of primitive religion and the cult of the dead, decorative motifs from the East, and a synthesis of the luxuriant nature that surrounded him. How does this silhouetted fence, with its mixture of primitive skulls and refined decorative forms from Asia, appear in a wilderness dominated by a distant idol? These motifs have never been seen together. But here they belong together, because together they create the sacred enclosure, an Olympus bathed in light and somewhere above the world of men. The baleful fence tells us we are shut out from it, and mortal, but the bright flowers remind us that this is still a world of life and lovely color. The painter has mixed flat surface and rounded forms, pure tones and chiaroscuro, outline and modeling. He has created a picture superficially inconsistent in both observation and technique, held together by the power of the imagined concept, expressing its philosophy through its abstraction.

92

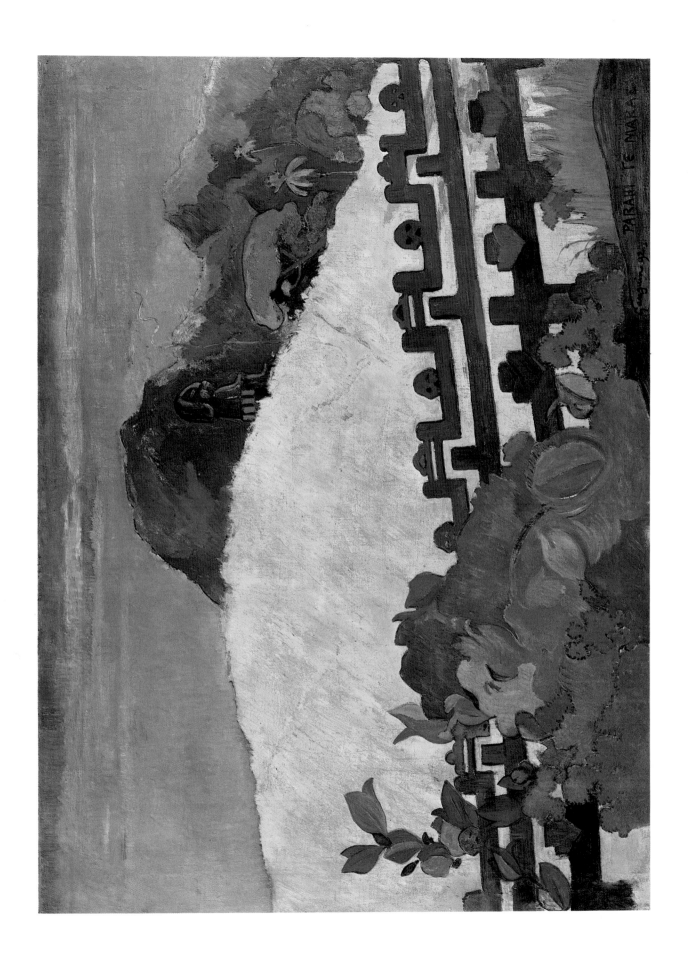

Painted in 1892

STILL LIFE WITH EXOTIC FRUIT

24 x 28¾" (61 x 73 cm.)
National Gallery, Oslo

IN TAHITI, WHEN GAUGUIN PAINTED STILL LIFES such as this one, it was as a relaxation from the effort of composing his larger pictures. "When I am tired of doing figures (my predilection) I begin a still life that I finish without a model," he wrote in 1900 to Emmanuel Bibesco. For despite the fact that even when he painted fruit and flowers Gauguin did not feel himself bound by the appearance of nature (its "accidents," as earlier esthetic theory might have put it), the effort of imagination was nevertheless a different one. In such simpler subjects he could concentrate on the "musical" side of his art, unconcerned with the problems of how such abstract constructions would reflect the character and meaning of the subject.

Here he has returned for once to a Cézanne solidity, modeling the fruit in color planes, establishing intervals of spatial recession on the table, building up a close harmony of hue that gives weight and concentration to the close-knit grouping. As in Cézanne, the back edge of the table to left and right does not connect in a single line, because more recession was needed on the right, and the structure of the fruits resembles his. But it is instructive to note—especially in view of the two men's contrasting public personalities—that where Cézanne's clear hues and tones so often produce a clarity that translates itself into feelings of confidence and even gaiety, Gauguin's darker, less contrasting harmonies seem to embody a more somber and subjective mood.

94

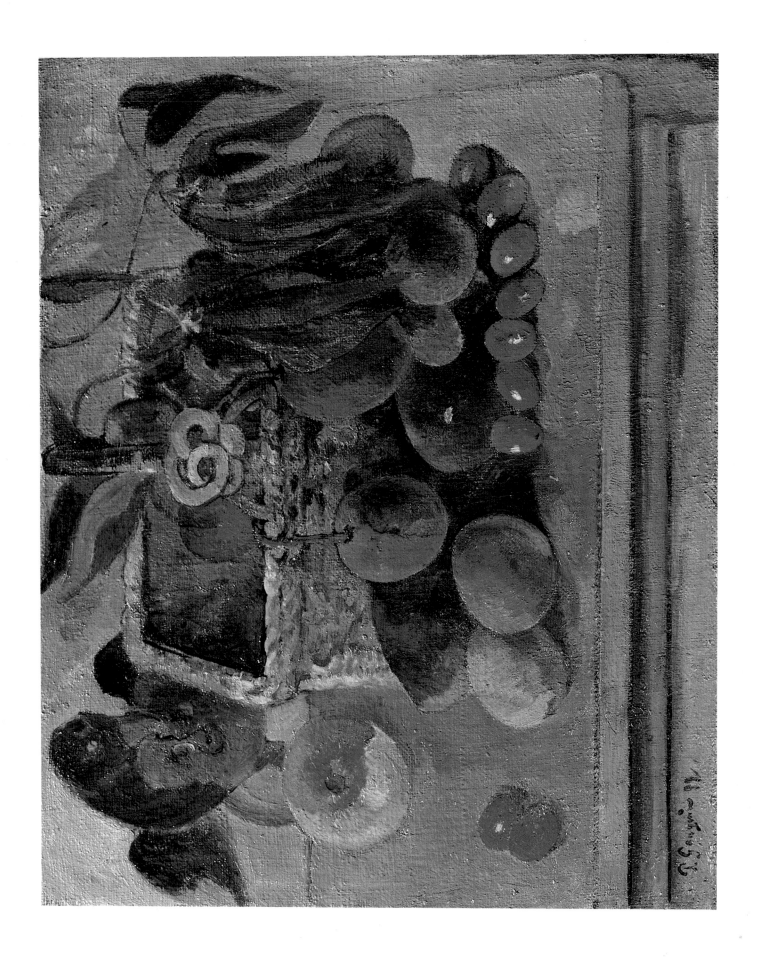

Painted in 1893

THE MOON AND THE EARTH

44¼ x 24″ (112 x 61 cm.)

The Museum of Modern Art, New York (Lillie P. Bliss Collection)

PREDISPOSED AS HE WAS toward the "mysterious," and living with the Tahitians, Gauguin naturally tended to legendary and mythological subjects. His allegorical figurations, such as the Moon and the Earth in this painting, can be traced back to no single source. They are compounded of memories of European painting, the stories of his Tahitian friends (especially Tehura, his young native wife), and his reading of native history and myth. Above all, they grow from a fundamental sense of symbolism—of an "enigma" that exists beneath the surface of the world's appearance. Here in Tahiti, as previously in Brittany, he tried to render this through the eyes of simple people, to capture something of their sense of wonder, and their acceptance of the incomprehensible workings of the universe.

The specific subject comes from a legendary dispute between Hina, the moon, and Fatou, the earth, that Gauguin (following Moerenhout) describes in his *Ancien Culte Mahorie*. Hina said to Fatou, "Make man live or rise again after death." Fatou answered, "No, I shall not revive him. The earth shall die, the vegetation shall die, it shall die like the men who feed upon it. . . ." "Do as you like, but I shall cause the moon to be reborn." The myth does little to explain Gauguin's rendering.

The canvas is curious in its mixture of the immense modeled figures and the flat patterns of motifs from nature, abstract and repetitive in form. It is almost as though Gauguin were saying that the myth, product of the imagination, is more real than any observation of nature. Contrary to traditional allegory, the scale of the symbolic figures is out of all proportion to their surroundings, so that far from being humanized, these gods loom before us powerful and terrible.

This picture was reproduced on the cover of the catalogue of Gauguin's exhibition at Durand-Ruel in November, 1893, when it was bought by Degas.

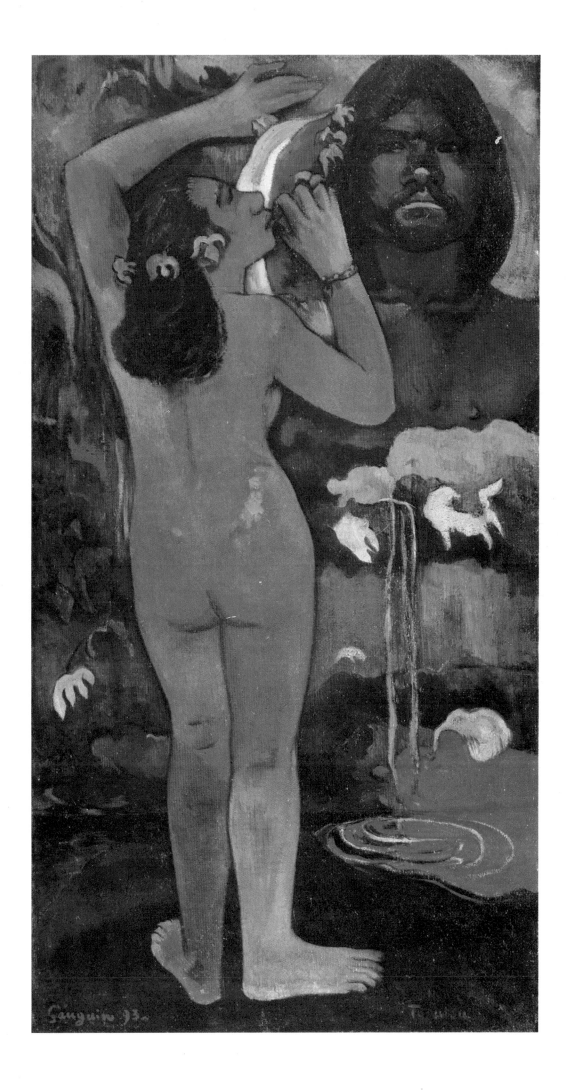

Painted in 1893

PORTRAIT OF THE ARTIST WITH A PALETTE

36¼ x 28¾" (92 x 73 cm.)

Pasadena Art Museum (Norton Simon Collection)

THIS SELF-PORTRAIT WAS PAINTED when Gauguin lived in the Rue Vercingé-torix, in a district behind the Montparnasse railroad station around which the Bretons come to Paris congregated. Back from the South Seas, the artist affected an exotic pose, and to the consternation of many, hung up in his studio examples of native art he had brought back with him. In this picture, apparently done from a photograph, since it shows his brush in the right hand, he is dressed in the costume described by his friend Armand Seguin (one of the artists of the "school of Pont-Aven"):

"In this astrakhan cap and enormous dark blue cloak held together by delicate metal clasps, he appeared to Parisians like a gorgeous and gigantic Magyar." For all its outlandish costume (compare some of Rembrandt's self-portraits) the picture has about it an air of dignity and repose, and a simplicity, that contrasts with the intensity and bravado, or alternately the irony and suffering found in most of the self-portraits.

The canvas is inscribed to Charles Morice, to whom Gauguin presented it. During his Tahiti stay he had accused Morice of having kept back moneys owed him, but they were reconciled in October, 1893. Morice then wrote the preface for the November, 1893 exhibition which Degas persuaded Durand-Ruel to present. In 1894 Gauguin and Morice began their joint work, *Noa Noa*.

98

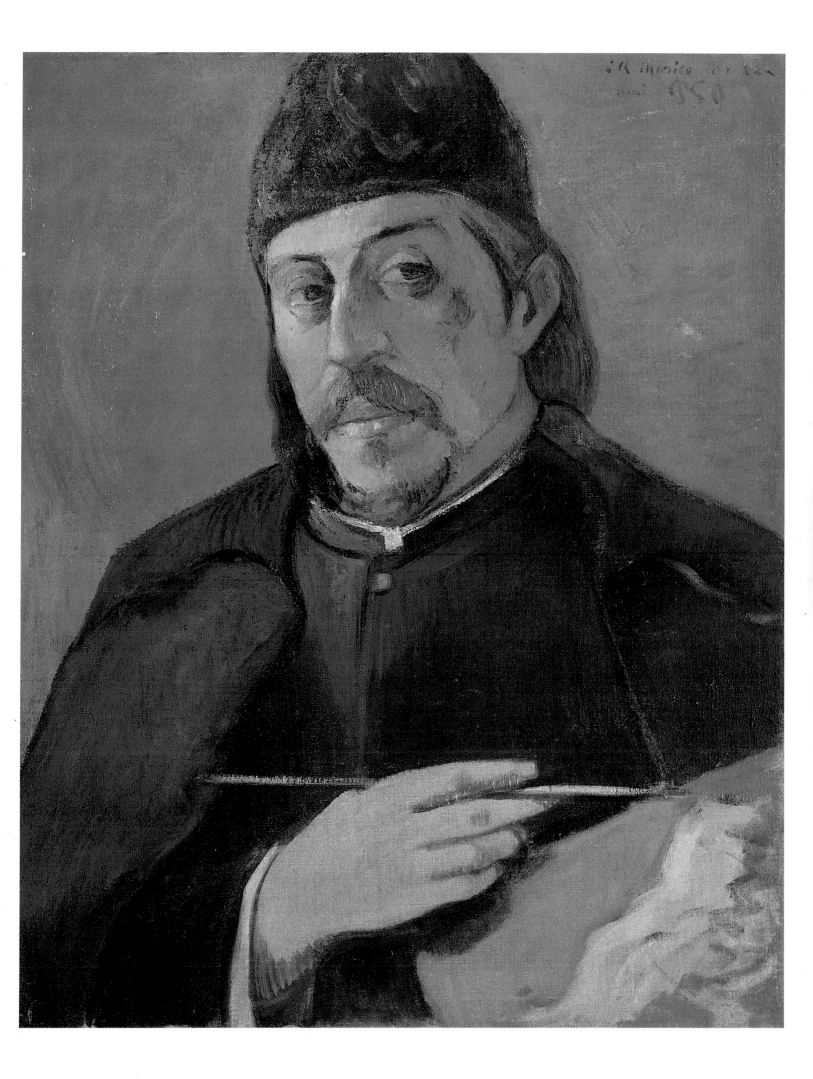

Painted in 1894

THE DAY OF THE GOD

26 x 34¼" (66 x 108 cm.)

The Art Institute of Chicago

LIKE THE MOON AND THE EARTH (page 96) this picture derives its theme from Gauguin's study and imaginative interpretation of Polynesian mythology. The main figure is Taaroa, central figure of the Maori pantheon, the creator of the world about whom the artist writes in his *Ancien Culte Mahorie*. In his honor gifts are being brought by two maidens on the left, while on the right two girls perform a ritual dance.

Gauguin's sources and his inventiveness are both clearly evident. The repetitive profiles of the white-clad girls (like those in the *Ta Matete* page 84) stem from Egypt; the dancers from his observation of the life around him, stylized to make a pendant group; and the god from his hieratic distillation of the myths he had read about. The three naked figures in the foreground seem to suggest creation, their languid poses (and especially the embryo curl of the figure on the right) related to the overpowering energy of the god behind them.

The curves of their figures, and of the god's feather headdress are echoed in the foreground. The water is filled with curious amoeba-like shapes, which, perhaps rocks, perhaps shadows (but from where?), are above all simply decorative forms designed to give the composition its mood and rhythm, and picked up again in the arbitrary cloud shapes of the background. We recognize here the synthetist simplifications of the Brittany pictures of 1888 and 1889. Now however, Gauguin has stylized them to the point of almost complete abstraction. Historically, they point forward, not back, and our first thought is no longer of leaded windows, source of Bernard's *cloisonnisme* but of post-Cubist, organic abstraction.

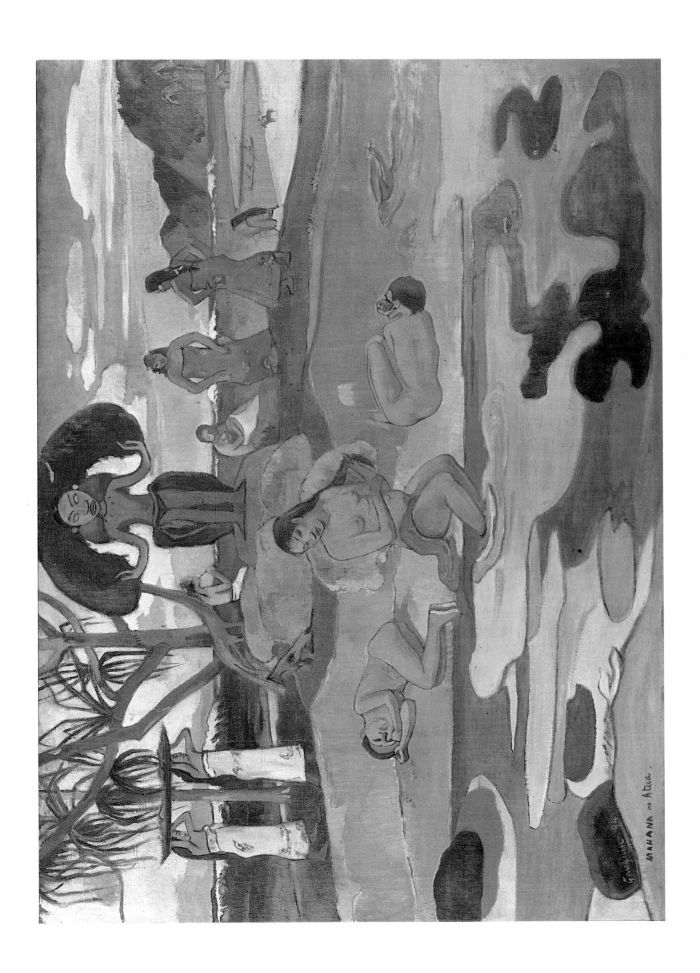

Painted in 1896

NAVE NAVE MAHANA

37⅜ x 51¼″ (95 x 130 cm.)
Musée des Beaux-Arts, Lyons

THERE IS A RECURRENT ASPECT OF GAUGUIN'S ART—and this calm canvas is an example of it—which is inevitably called decorative. Sometimes his designs, rhythmic and slow, suggest the narrow, billowed-out relief space of a sculptured frieze. For this canvas, richer in color harmony, more fused in tone, tapestry is perhaps the closer parallel. The composition is filled by the tall figures, which almost touch its borders, by the trees, which go beyond them, and the horizontal bands of ground and sky, so that every spot is as rich and articulated as any other. The color areas, whether of bodies or *pareos*, whether of tree trunks or leaves, or earth or light-filled golden air, are large and well defined. But they have been softened to give them a rich and sensuous texture, as if by some enveloping atmosphere, or some heavy woven material that affects all surfaces alike and removes them into the unreality of an ideal, distant, and silent land.

The strong repeated verticals of the figures are lightened just enough by their bodies' grace so that they have the long rhythms of the ground and hills, and the seated figures, whose smaller scale gives size to the whole, repeat the shorter, rounder curves of the plant in the foreground and the branches and leaves above.

The idylls of Puvis de Chavannes have been evoked as comparisons to this picture ("Puvis overwhelms me with his talent," wrote Gauguin, and he put a copy of Puvis' *Hope* [page 37] into one of his last paintings). And to be sure, there is the nostalgia for a simpler existence in both artists. But Puvis views his Classic landscapes through a telescope from some distant Olympus, while Gauguin brings his tropical version close and warm before us. Here there is no mystery, no exoticism, no irony. This is simply Anacreon in native dress: the Classic tradition carried halfway round the world.

102

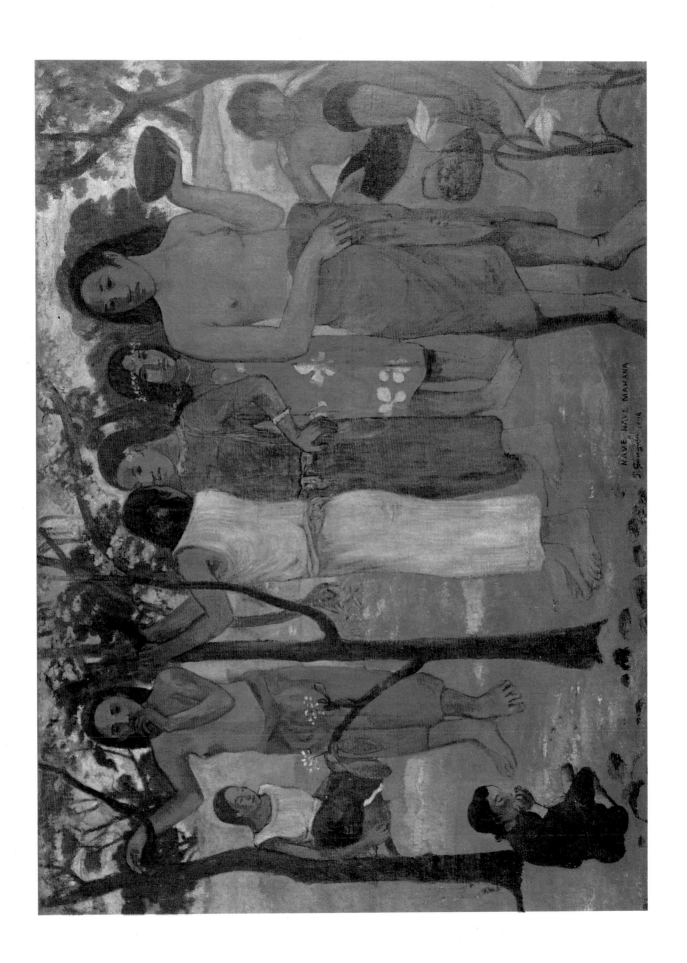

Painted in 1896

MATERNITY

36¾ x 23½" (92.5 x 60 cm.)

Private collection, United States

FAMILY GROUPS WERE A REPEATED THEME in Gauguin's art, especially those of mothers and children. Despite his apparent coldness, and his stubborn determination to put his art above everything else, Gauguin could not forget his own isolation, nor forgive his wife that it was she, not he, who was granted the comfort of their children's companionship. In friendly moods he imagined them all reunited, ending their lives together—"with white locks [we will] enter a period of peace and spiritual happiness, surrounded by our children, flesh of our flesh"—a dream that was never to be. Perhaps it was the painful contrast that drew him to the domestic contentment of the Tahitians.

But this picture is no genre anecdote of the primitive, full of realistic detail and incident. On the contrary, it has been stripped of all but its essential symbols of love and care: the nursing mother, guarded, as it were, by watchful and protective sisters; the fruit, of abundance; and the flower, of beauty. We do not know where they are, except that it is in some tropical garden of Arcady (and Poussin would indeed have recognized the group). Earth and sky (distinguishable only in color), move upward behind the group in soft, rounded shapes that echo the flowing contours of the figures. The warm colors of the foreground, in close harmony, suggest the warmth and contentment of the human scene and close it in, yet open out into the note of gaiety of the brilliant hues of the sky beyond.

104

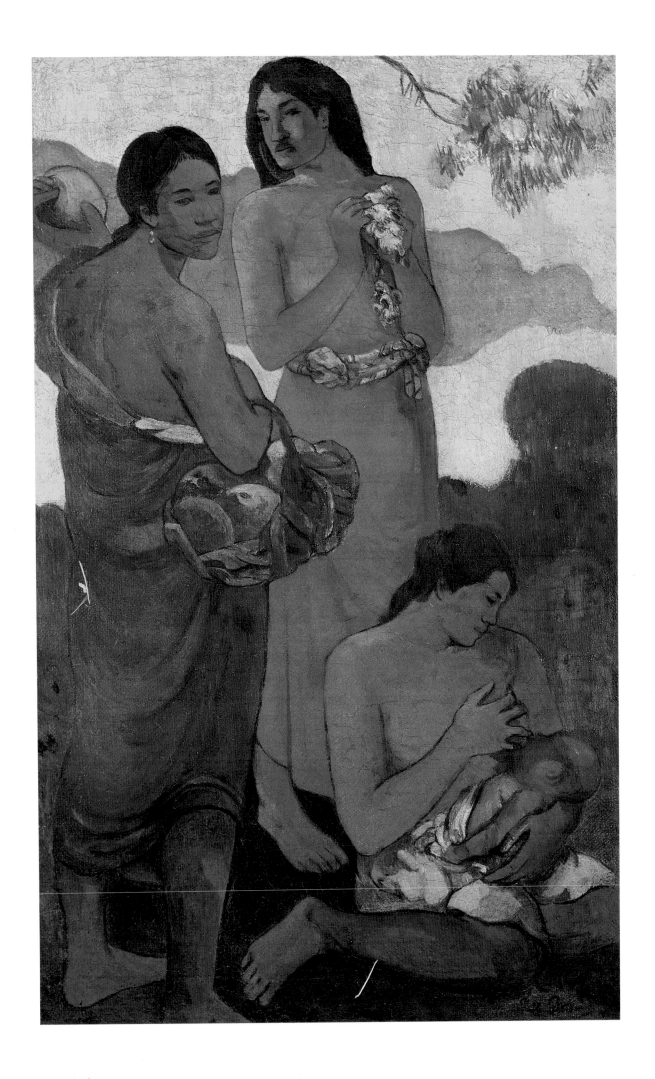

Painted in 1896

NATIVITY

37¾ x 50¾" (96 x 129 cm.)
Bavarian State Painting Collections, Munich

IN JULY, 1896, TEN MONTHS AFTER HIS SECOND ARRIVAL in Tahiti, Gauguin
wrote to Daniel de Monfreid: "I am not unreasonable, I live on 100 francs
a month, I and my *vahiné,* a young girl thirteen and a half years old. You
see that it is not much; it provides me with tobacco and soap and a dress
for the little one. If you could see my setup! A thatched house with a studio
window, two trunks of cocoanut trees carved in the form of native gods,
flowering bushes, a shed for my cart, and a horse. Yes, I have spent money
on a house so as no longer to have to pay rent, and to be sure to have a
roof over my head . . ." And in November he wrote that he was about to
become a father.

Here then was the setting for this Nativity scene, whose religious allusion
is barely suggested by the pale yellow and green halos of the mother and
child and the animals behind. It is very different from that other biblical
picture of five years earlier, *Ia Orana Maria:* that is a traditional subject
with native actors, as if to widen a Western parochialism; here a native
scene, sacred less because of any specific iconographic connotation than for
what it is in itself, an event at once personal and universal. The light around
the whole figure contrasts with the mysterious gloom beyond (and the
carved trees and native gods of Gauguin's letter); its warm glow, rather
than the circles around the heads, is the true halo of the painting, sugges-
tion replacing description. The relaxed hands of the mother, the heads of
the infant and the women beyond show a tenderness Gauguin often hid.

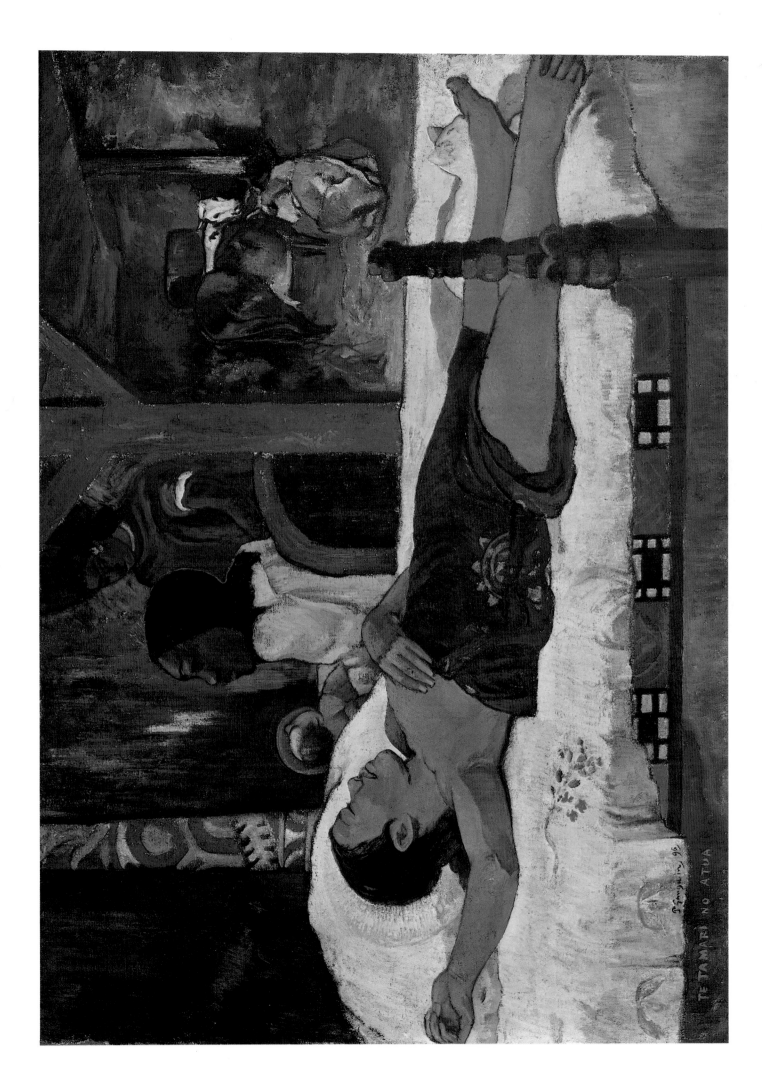

LE REPOS

AS HIS STYLE PROGRESSED, Gauguin felt freer to organize his pictures upon an "abstract" rhythmical order. Objects were viewed straight on, at eye level, and such perspective as there was tended to be arbitrary. Therefore this painting is exceptional in composition. Perhaps it was the intimate subject, the interior scene examined without symbolic overtones that suggested to Gauguin the use of this angular view and sharply receding perspective. The figures seen at close range from above, the sudden truncation of floor and walls again recall Impressionism. Perhaps for Gauguin they were reminiscent of Degas, whom he admired for his honesty, his taste (since Degas bought a number of Gauguin's pictures!), his biting wit, and his impeccable drawing.

No doubt Gauguin's house did not have quite this immaculate and empty appearance. He has rendered it somewhat finer than life, brought out its essential, uncluttered structure, as all painters of interiors from the Dutch masters on have been inclined to do. He tells in his letters of putting his pictures on the wall, and of decorating his different houses with specially designed works. The wall on the left seems to be embellished in this fashion; the amorous group in its center was one of his favorites, variations of it appear in his woodcuts and his sculpture.

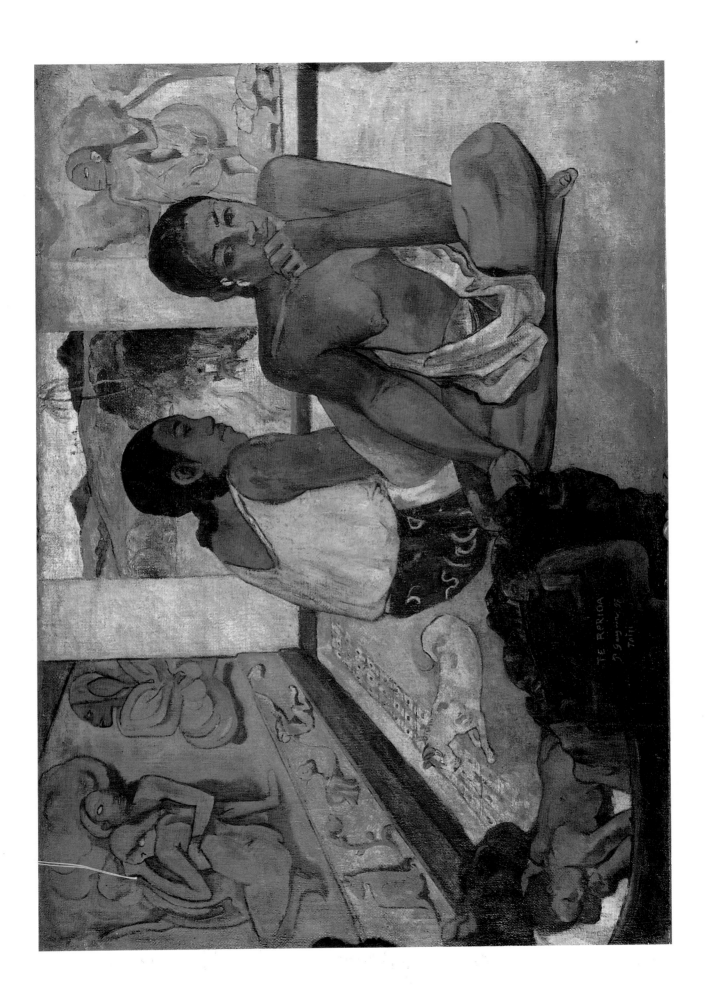

Painted in 1897

WHERE DO WE COME FROM?

(*detail from* WHERE DO WE COME FROM? WHAT ARE WE? WHERE ARE WE GOING?)

Whole picture 55½ x 148¼″ (141 x 376 cm.)

Museum of Fine Arts, Boston

IN DECEMBER, 1897, GAUGUIN DECIDED TO KILL HIMSELF. He was sick and miserable, without enough money for medical treatment, he was in debt and abandoned by those who owed him money. His tropical paradise had failed. He wished, before dying, to paint one great, last testamentary picture, and summoning all his strength in a single burst of energy he painted this canvas—his largest. The attempt at suicide (apparently through an overdose of the arsenic he took) failed, and so in later letters, we have his own comments upon the picture and its genesis:

"It is a canvas about five feet by twelve. The two upper corners are chrome yellow, with an inscription on the left, and my name on the right, like a fresco on a golden wall with its corners damaged.

"To the right, below, a sleeping baby and three seated women. Two figures dressed in purple confide their thoughts to each other. An enormous crouching figure which intentionally violates the perspective, raises its arm in the air and looks in astonishment at these two people who dare to think of their destiny. A figure in the center is picking fruit. Two cats near a child. A white goat. An idol, both arms mysteriously and rhythmically raised, seems to indicate the Beyond. A crouching girl seems to listen to the idol. Lastly, an old woman approaching death appears reconciled and resigned to her thoughts. She completes the story. At her feet a strange white bird, holding a lizard in its claw [sic], represents a futility of words.

"The setting is the bank of a stream in the woods. In the background the ocean, and beyond the mountains of a neighboring island. In spite of changes of tone, the landscape is blue and Veronese green from one end to the other. The naked figures stand out against it in bold orange.

"If anyone said to the students competing for the Rome Prize at the Ecole des Beaux-Arts, the picture you must paint is to represent *Where Do We Come From? What Are We? Where Are We Going?* what would they do? I have finished a philosophical work on this theme, comparable to the Gospels. I think it is good."

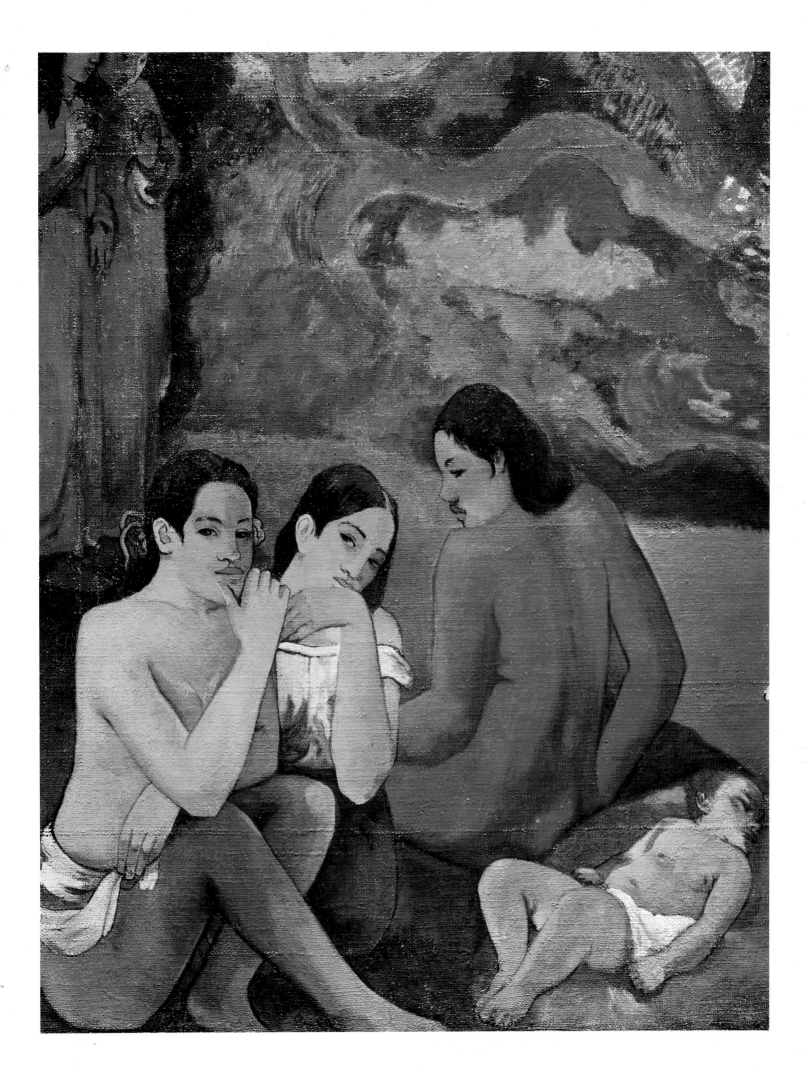

Painted in 1897

WHAT ARE WE?

(*detail from* WHERE DO WE COME FROM? WHAT ARE WE? WHERE ARE WE GOING?)

Whole picture 55½ x 148¼″ (141 x 376 cm.)

Museum of Fine Arts, Boston

GAUGUIN DID MORE THAN DESCRIBE the allegorical subject of this picture. He also told of the method and manner of its execution, stressing what his predecessors in romanticism would have called inspiration, and his twentieth-century heirs the uncontrollable workings of the subconscious, true source of the artist's genius:

"I worked day and night that whole month in an incredible fever. Lord knows it is not done like a Puvis de Chavannes: sketch after nature, preparatory cartoon, etc. It is all done from imagination, straight from the brush, on sackcloth full of knots and wrinkles, so the appearance is terribly rough.

"They will say it is careless, unfinished. It is true that one is not a good judge of one's own work, nevertheless I believe that this canvas not only surpasses all my previous work, but that I will never do anything better or even like it. Before dying I put into it all my energy, a passion so painful, in terrible circumstances, and a vision so clear, needing no correction, that the hastiness disappears and life surges up. It doesn't smell of the model, of conventional techniques and the so-called rules—from all of which I have always liberated myself, though sometimes with trepidation . . .

"I look at it incessantly and (I admit) I admire it. The more I study it, the more I realize its enormous mathematical faults, which I will not correct at any price. The painting will stay as it is—as a sketch, if you wish.

"But there is also this question which perplexes me: Where does the execution of a painting begin, and where does it end? At the very moment when the most intense emotions fuse in the depths of one's being, at the moment when they burst forth and issue like lava from a volcano, is there not something like the blossoming of the suddenly created work, a brutal work, if you wish, yet great, and superhuman in appearance? The cold calculations of reason have not presided at this birth; who knows when, in the depths of the artist's soul the work was begun—unconsciously perhaps?"

112

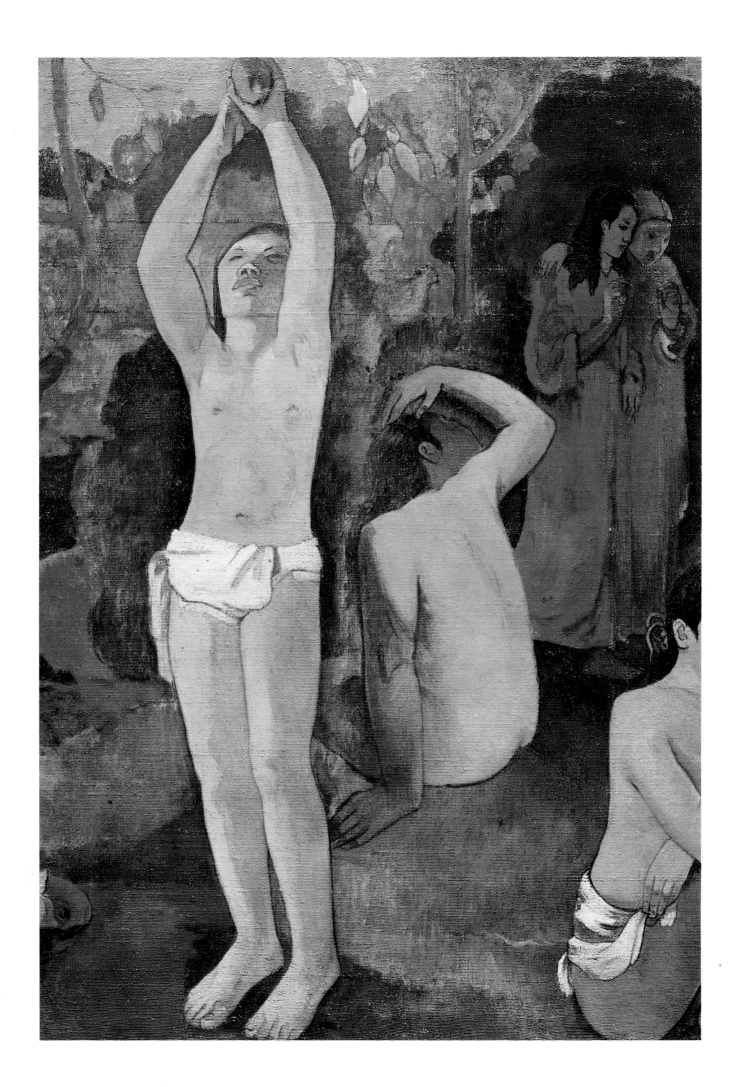

Painted in 1897

WHERE ARE WE GOING?
(*detail from* WHERE DO WE COME FROM? WHAT ARE WE? WHERE ARE WE GOING?)

Whole picture 55½ x 148¼" (141 x 376 cm.)

Museum of Fine Arts, Boston

AFTER GAUGUIN RECOVERED, in the spring of 1898, he sent the picture on to Paris, where it was shown at Ambroise Vollard's gallery. There it attracted considerable attention, and the critic André Fontainas discussed it at some length, sympathetically, but from a conventional point of view. For him the picture lacked any clear content; "There is nothing," he wrote, "that explains the meaning of the allegory."

In a letter of March, 1899, Gauguin took the trouble to reply at some length, writing in what was for him a very friendly tone, to explain his method and intention. After mentioning the "musical" role that color plays in his pictures (and will play increasingly in modern painting—a prophetic statement), and its power of evoking "what is the most general, and by the same token the most vague in nature—its interior force," he continues:

"My dream is intangible, it implies no allegory; as Mallarmé said, 'It is a musical poem and needs no libretto.' Consequently the essence of a work, unsubstantial and of a higher order, lies precisely in 'what is not expressed; it is the implicit result of the lines, without color or words; it has no material being.' . . .

"The idol in my picture is not there as a literary explanation, but as a statue; is perhaps less of a statue than the animal figures, and is also less animal, since it is one with nature in the dream I dream before my hut. It rules our primitive souls, the imaginary consolation of our suffering, vague and ignorant as we are about the mystery of our origin and our destiny.

"All this sings with sadness in my soul and my surroundings, while I paint and dream at the same time with no tangible allegory within my reach— owing perhaps to the lack of literary education.

"Awakening with my work finished, I say to myself, *Where Do We Come From? What Are We? Where Are We Going?* A thought which no longer has anything to do with the canvas, expressed in words quite apart on the wall which surrounds it. Not a title, but a signature . . .

"I have tried to put my dream into a suggestive setting and to interpret it without recourse to literary means and with all the simplicity the medium allows: a difficult task. Criticize me if you wish for having failed, but not for having tried . . ."

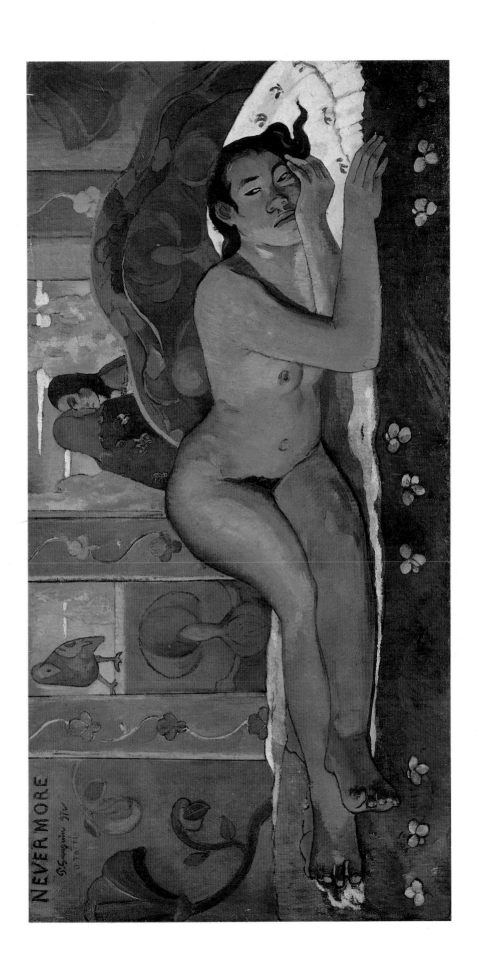

Painted in 1898

THE WHITE HORSE

55½ x 35¾" (141 x 91 cm.)

Museum of Impressionism, The Louvre, Paris

HERE IS A COMPOSITION THAT RISES with a continuous flow of curves from bottom to top, an arrangement without a horizon, in which space is suggested rather than rendered. Horizontal and vertical planes (the pool and plants of the foreground, and the road and twining branches of the background) flow into each other, all painted in a perspective that views the scene at once from in front and from above. This, and the twisting, curving pattern of the horses' backs, the leaf forms, and the climbing vine trunks hark back to the Japanese print. The flat pattern and raised perspective of the Japanese woodcut had been major sources of Gauguin's style in Brittany, but in Tahiti their influence had diminished. Here Gauguin seems to recall that style, but he has softened and varied it. Horses and riders are more modeled than the rest (although they go up as they go back, as in oriental art), and there is an almost Impressionist variation of light and texture within the areas of pool and field. Most naturalist of all, the "white" horse (whose movement seems like the symbolic gesture of a pawing Pegasus out of Redon's imaginative art), is painted grayish-green because the light upon it has been filtered through the leaves above. Isolated and riderless, self-contained in an otherwise active composition, its mystery and strangeness spreads, and suffuses the whole painting.

118

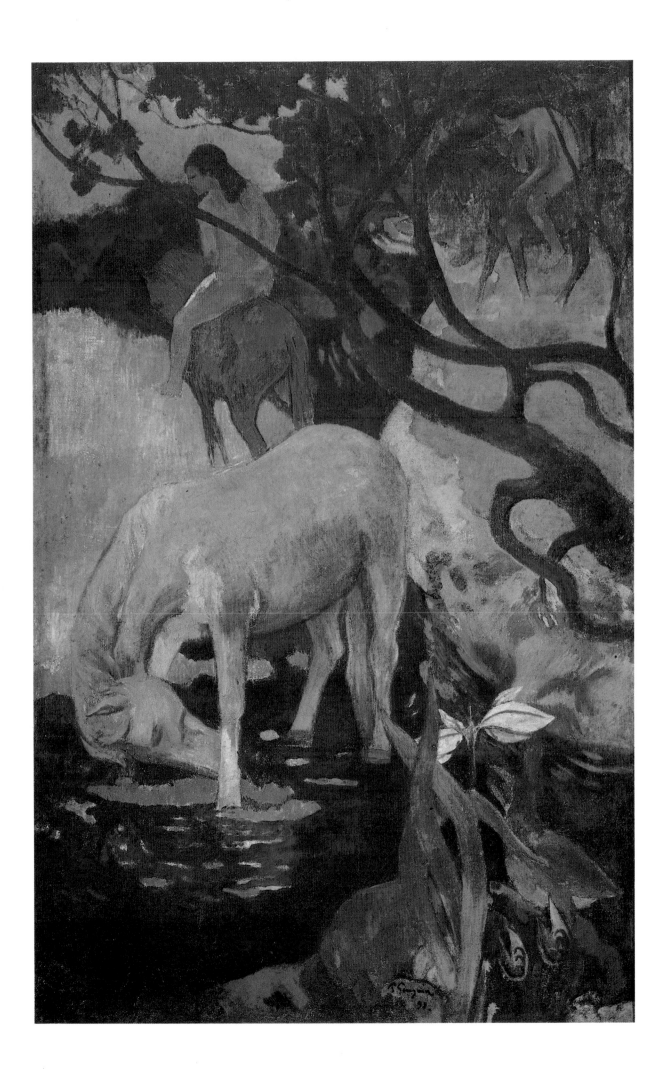

Painted in 1899

TAHITIAN WOMEN
WITH MANGO BLOSSOMS

37 x 28¾" (94 x 73 cm.)

The Metropolitan Museum of Art, New York (William C. Osborn Collection)

GAUGUIN WENT FAR TO FIND HIS GARDEN OF EDEN. He arrived with its lovely and mysterious image, drawn in part from his own desires, already partially fixed in his mind's eye; otherwise he could hardly, in cold blood and with an objective vision, have mustered up the courage to seek it out. Therefore he rarely looked at his surroundings as they were, rarely painted them without some added elements of his ideal vision, no matter how often, in retrospect, he understood that this had been deceived.

This canvas does achieve that sort of simplicity. It is a study of the nude, with no admixture of the programmatic. Perhaps for this reason it is softer than many of Gauguin's pictures. The bodies are modeled, the colors light in tone. Gauguin wrote with admiration of the erect stature, the broad shoulders, the strength with grace of the Polynesian women. Here he has rendered that impression.

And he has done something more. Contrary to the figures of other paintings—*Spirit of the Dead Watching*, or *The Day of the God*, or *Nevermore*, these women are not veiled in a mythological tradition, they simply confront us. Gauguin might have been writing of them (though they were painted later) in his reply to August Strindberg, when he professed not to understand Gauguin's exotic world:

"Before the Eve of my choice, that I have painted in the forms and harmonies of another world, your favorite memories have perhaps recalled an unhappy past. The Eve of your civilized conception makes you, makes almost all of us misogynist; [but] that ancient Eve, who frightens you in my studio, may one day smile at you less bitterly . . .

"The Eve that I have painted (she alone) can logically remain nude before our eyes."

120

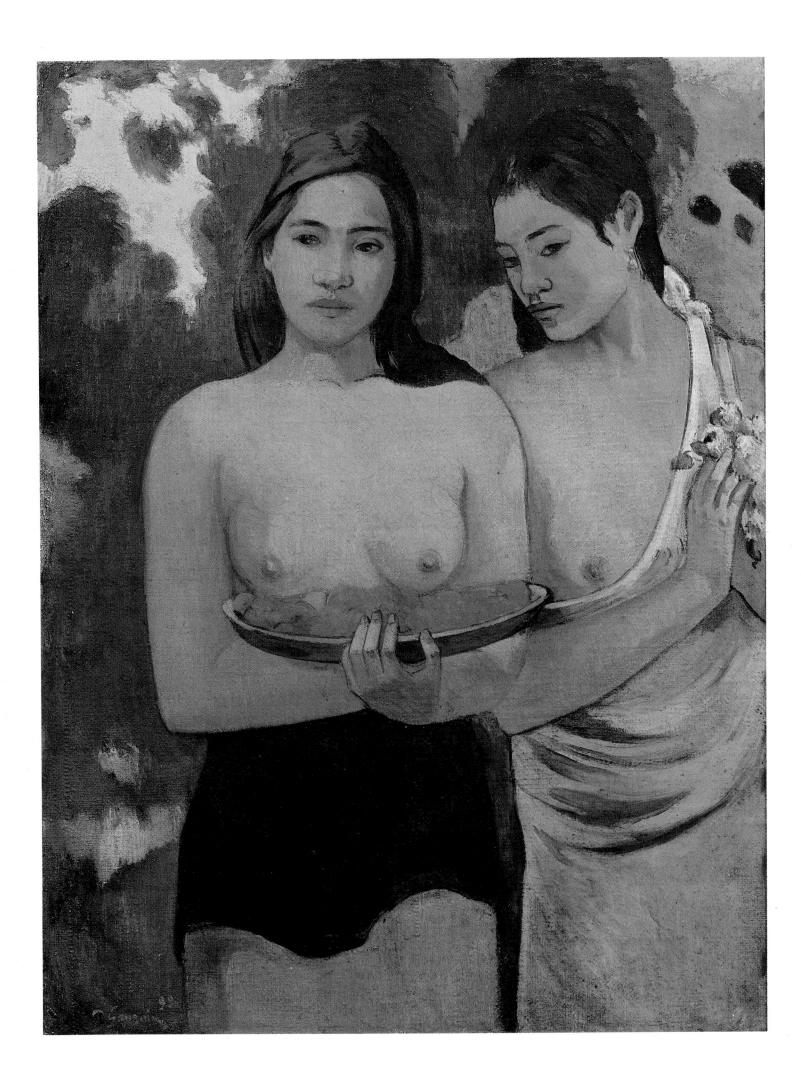

Painted in 1902

CONTES BARBARES

54¼ x 35½" (130 x 89 cm.)
Folkwang Museum, Essen

GAUGUIN HAD A "TERRIBLE ITCHING FOR THE UNKNOWN—which makes me commit follies," and which drove him on, both in his life and in his painting. He also had a strange kind of faithfulness (or nostalgia), to his earlier self, and to the origins of his art. However far he left Paris behind, however much he loved the tropics, he was still an exile from France, and a conscious exile from the European tradition.

The elements of this picture bear witness to the diversity of its sources, and how the painter has joined his own past and present—part of that present an imaginary one. The face of the storyteller in blue, crouched, and cramped by the frame, with deformed features and clawed feet, repeats a portrait of his dwarfed Dutch painter friend Meyer de Haan with whom he had worked in Brittany in 1889. The central figure is in an idol-like position, often used by Gauguin to suggest a legendary theme. And the girl on the right, more delicate-featured, with flowers in her hair, and seated in a field of flowers, reminded the critic Charles Morice (one can see why) of Botticelli. The composition, with its sharp diagonal of the ground rising to the right, and the people rising to the left, recalls the flattened symbolic arrangements of his Brittany pictures of the eighties, influenced by Japanese prints. From these varied, and still evident sources the painter has created a painting which holds together because of a pictorial unity—yet is strange because of the strangeness of its many origins.

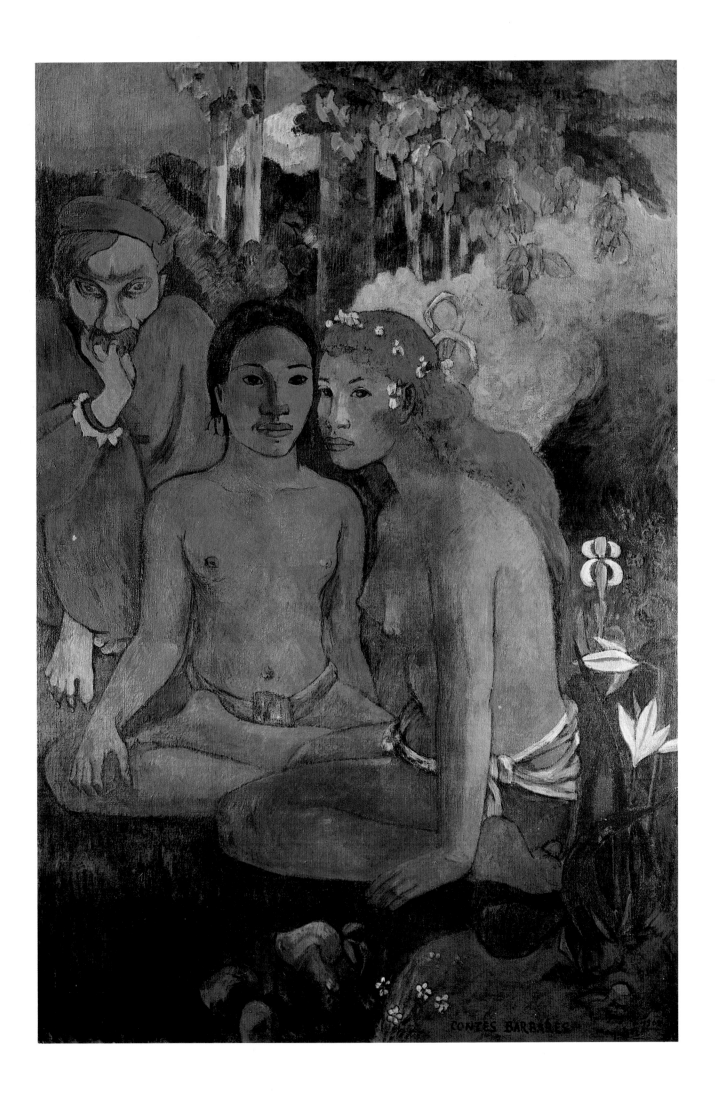

Painted in 1902

THE CALL (L'Appel)

51¼ x 35½" (130.2 x 89.5 cm.)

The Cleveland Museum of Art (Gift of Hanna Fund)

SEDUCED BY THE SPECTACLE OF NATURE he had come so far to see, but driven also by the vision of a painting somehow beyond nature and susceptible to the literary ideas of his time, Gauguin was constantly torn between painting what lay before him, and rendering his mind's image. Ideally, the two should merge into one vision, a poetic form that would marry external nature to inner meaning. In practice, each painting tended more in one direction or the other.

This canvas was painted in the Marquesas when Gauguin was living in that "vast atelier, with one small corner to sleep in . . . a hammock protected from the sun for a siesta, refreshed by a sea breeze that comes through the cocoanut palms from the shore a thousand feet off." A passage from this same letter to his friend Daniel de Monfreid will serve as its text: "You know what I think of all those false literary ideas—Symbolist or any other —in painting . . . Here in my isolation I have more than enough [nature] in which to steep myself once more. Here poetry wells up by itself, and one has only to permit oneself to fall into revery as one paints in order to suggest it." And in this picture the energetic painter is in a receptive mood. He has allowed a poetry of place, a feeling of this particular spot to penetrate him, so that nature and figures all are one. The frieze arrangement he so often employs is evident again here. The massive seated figure to the left, which he has employed in other compositions, and the bands of colored ground with their irregular patterns are drawn into abstract shapes. Though he wrote "The great error is the Greeks," the figure on the right whose gesture gives the picture its title derives from the Parthenon frieze. The color harmony, especially the narrow gamut of reds and pinks, lavenders and violets, purples and blues, is Gauguin's own. Yet despite the powerful elements of personal style, this is no imagined landscape. He knew it and loved it well. "I am contented, here in my solitude."

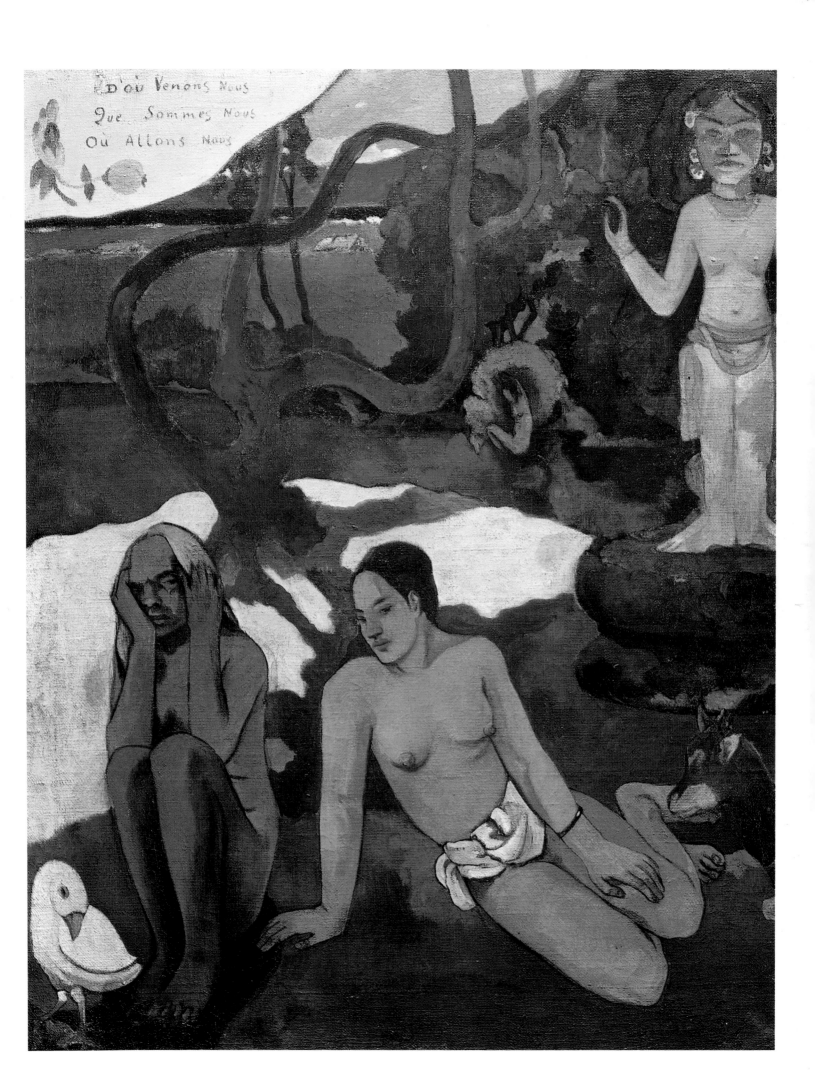

Painted in 1897

NEVERMORE

23¾ x 45¾" (60.3 x 116.2 cm.)

Courtauld Institute of Art, Courtesy of The Home House Trustees, London

LIKE THE SPIRIT OF THE DEAD WATCHING of five years earlier, this picture can be seen as a "simple study of an Oceanic nude." Here too there is a reminiscence of the composition of Manet's *Olympia*, which Gauguin admired, and the clear, continuous outline around the figure suggests the earlier artist's anti-Impressionist use of conventional contour. But the mood of the painting is far from Manet's cool vision. It shows how much Gauguin's romantic imagination often quite consciously affected the interpretation of his surroundings, which were frequently squalid, and, for a realist, without charm. Gauguin was no realist:

"I wanted to make a simple nude suggest a certain barbaric splendor of times gone by. The whole painting is bathed in colors that are deliberately somber and sad. Neither silk nor velvet, neither batiste nor gold creates this splendor, but simply paint enhanced through the artist's skill. No tricks [but] imagination alone has by its fancy enriched this dwelling.

"For a title, *Nevermore;* not 'The Raven' of Edgar Poe, but a bird of the devil who watches."

Even here Gauguin has employed a frieze technique. He has echoed the curves of the nude in the outline of the bedstead and in the stylized floral patterns on the wall, beneath the title, and around the raven. But these freely drawn shapes are held tightly in the rigid verticals of the architecture. Between its rhythmic intervals we are allowed brief glimpses of a space beyond, which only increases the element of mystery within. Here, if anywhere, Mallarmé's enigmatic phrase applies: "It is extraordinary to be able to put such mystery into such brilliance."

116

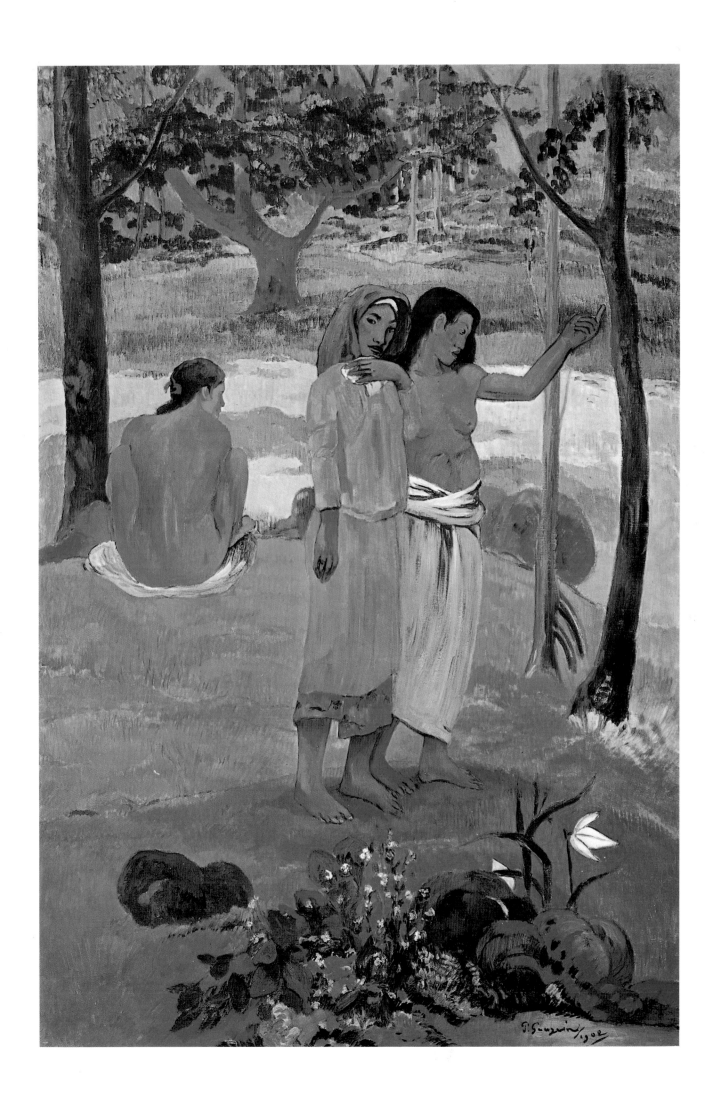

Painted in 1902

RIDERS ON THE BEACH

29½ x 36½" (75 x 93 cm.)

Collection Stavros Niarchos

THROUGHOUT HIS LIFE GAUGUIN HAD ADMIRED DEGAS, and in *Avant et Après,*
written in January and February of 1903 (only a few months after this pic-
ture was executed), Degas is the contemporary painter most frequently
mentioned.

In that same manuscript Gauguin also wrote: "Study the silhouette of
every object; distinctness of outline is the attribute of the hand that is not
enfeebled by any hesitation of will." It was indeed for such incisiveness
of vision (as well as of wit and will so like his own) that he admired Degas.

This picture, painted on that shore of Atuana which he could see from
his last native home, seems created out of a reminiscence of Degas' paint-
ings and exemplifies the power that Gauguin, sick though he was, kept until
the end. For though its setting is so different from Degas' elegant scenes of
the Longchamps track, its space, its isolation of the figures, its clarity of
outline that makes of each horse a closed form, and the sense of rhythmic
interval, all are akin to the older master's vision. And the handling suggests
both the past and the future: the brush strokes of the sky, even its color,
reach back to the Impressionists, but the pink of the foreground, which is
Gauguin's own, points forward toward the Fauves. And not only the Fauves,
for these pastel shades, the sparseness of the horses, and the symbolic short-
hand of the two on the upper right, are close in feeling to pictures of
Picasso, done only a little later.

"I have wished to establish the *right* to dare anything . . . ," wrote Gauguin
just before he died, "the public owes me nothing, since my achievement in
painting is only *relatively* good, but the painters—who today profit by this
liberty—they owe something to me."

126

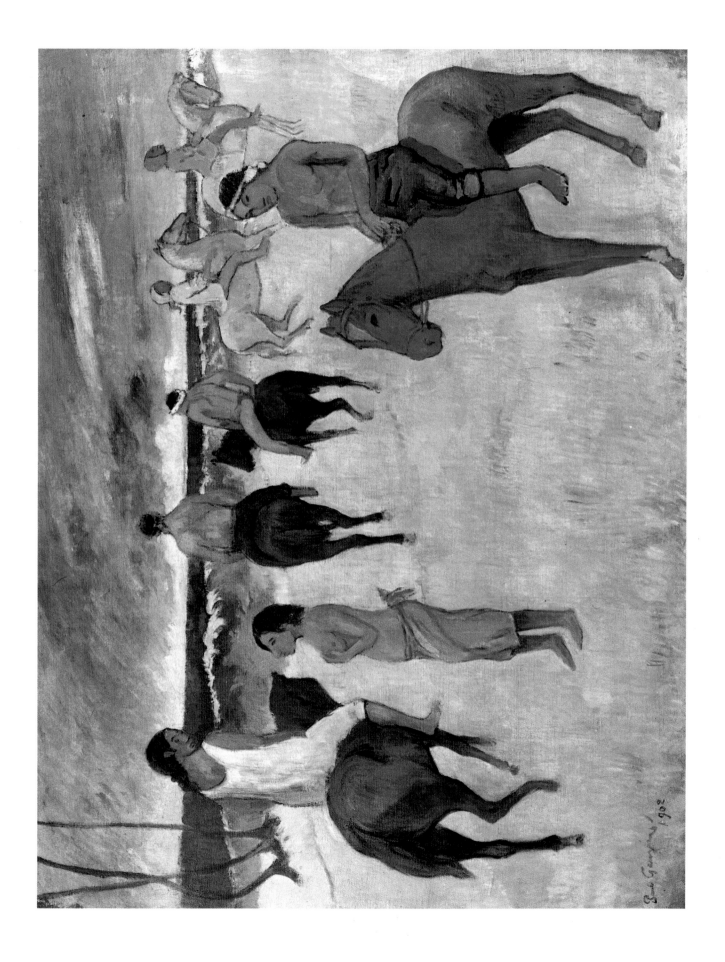

ACKNOWLEDGMENT

*The author and the publishers wish to express their gratitude
to the museums, galleries, and private collectors who so kindly gave their
permission to reproduce the works in their possession. An extra measure of gratitude
goes to the following, for their helpfulness and interest: Mme. A. Joly-Ségalen,
William S. Lieberman, John Rewald, and Vladimir Visson.*